REPRESENT!

embroidery

**STITCH 10 COLORFUL PROJECTS &
100+ DESIGNS Featuring a Full Range of
Shapes, Skin Tones & Hair Textures**

Bianca Springer

stash BOOKS

an imprint of C&T Publishing

Text and artwork copyright © 2022 by Bianca Springer

Photography provided by or paid for by Bianca Springer copyright © 2022 by Bianca Springer

Photography paid for by C&T Publishing, Inc. copyright © 2022 by C&T Publishing, Inc.

PUBLISHER: Amy Barrett-Daffin

CREATIVE DIRECTOR: Gailen Runge

ACQUISITIONS EDITOR: Roxane Cerda

EDITORS: Madison Moore and Karla Menaugh

TECHNICAL EDITOR: Gailen Runge

COVER/BOOK DESIGNER: April Mostek

PRODUCTION COORDINATOR: Zinnia Heinzmann

ILLUSTRATORS: Lauren-Ashley Barnes, Kirin Herbert, Kirstie Pettersen, and Bianca Springer

PHOTO ASSISTANT: Gabriel Martinez

COVER PHOTOGRAPHY by Kelly Sweet Photography

INSTRUCTIONAL PHOTOGRAPHY by Bianca Springer; LIFESTYLE AND SUBJECTS PHOTOGRAPHY by Kelly Sweet Photography, unless otherwise noted

GRAPHIC ELEMENTS IMAGES: Eaks1979/Shutterstock.com, VolodymyrSanych/Shutterstock.com, and Ron Dale/Shutterstock.com

Published by Stash Books, an imprint of C&T Publishing, Inc., P.O. Box 1456, Lafayette, CA 94549

Library of Congress Cataloging-in-Publication Data
Names: Springer, Bianca, 1976- author.
Title: Represent! embroidery : stitch 10 colorful projects & 100+ designs featuring a full range of shapes, skin tones & hair textures / Bianca Springer.
Description: Lafayette, CA : Stash Books, an imprint of C&T Publishing, Inc., [2022]
Identifiers: LCCN 2022010289| ISBN 9781644031810 (trade paperback) | ISBN 9781644032398 (ebook)
Subjects: LCSH: Embroidery. | Embroidery--Patterns.
Classification: LCC TT771 .S695 2022 | DDC 746.44/041 23/eng/20220--dc03
LC record available at https://lccn.loc.gov/2022010289

Printed in China

10 9 8 7 6 5 4 3 2 1

DEDICATION

This book is for my family. Mum, you taught me to never shrink to fit anywhere too small for me, to own the space I inhabit, and to trust and use my voice. Raquel, thank you for being my protector, fierce supporter, and brave warrior in all things. Justin, thank you for speaking life over me and speaking encouragement over my doubts. Thank you for trusting my vision and celebrating every victory, both big and small. Emerson and Gabriel, thank you for being endless sources of creative inspiration and action. You two have expanded my heart, my worldview, my urge to fight and my desire to make the world better for you.

ACKNOWLEDGEMENTS

This is a book that I have wanted and needed on my crafting journey, and I am thrilled to be able to share it with you. I am grateful to my acquisitions editor, Roxane, for hearing my frustrations with what I felt was missing in the embroidery market and for working with me to get here. Thank you to the entire C&T team for helping me get these ideas out of my head and into my hands. Karla, thank you for your patience, tireless guidance, and direction throughout. Thank you Latifah, Kelly, Teresa, and Hillary. Along the way, when I have questioned this project for one reason or another, you each have given me a reason, encouragement, and guidance on how to move forward. Also, thank you Lauren-Ashley and Kirin for your amazing work illustrating my concepts. I loved that you "got it" when I described what I needed and in many ways exceeded my expectations.

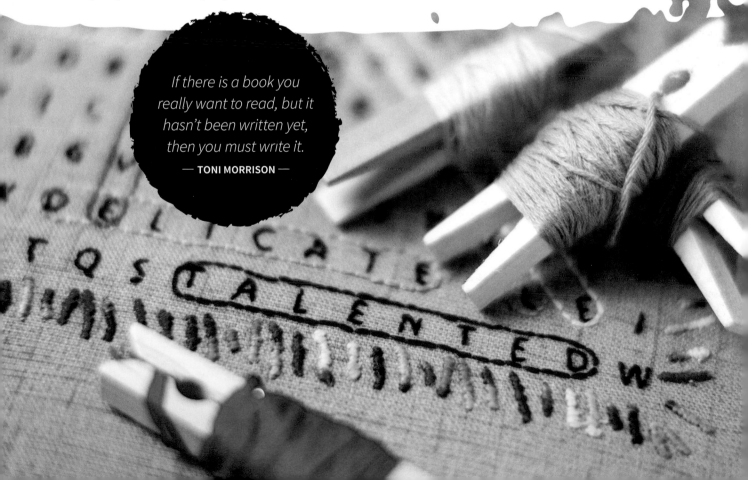

If there is a book you really want to read, but it hasn't been written yet, then you must write it.

— **TONI MORRISON** —

Contents

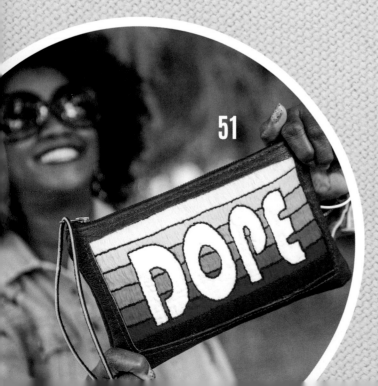

51

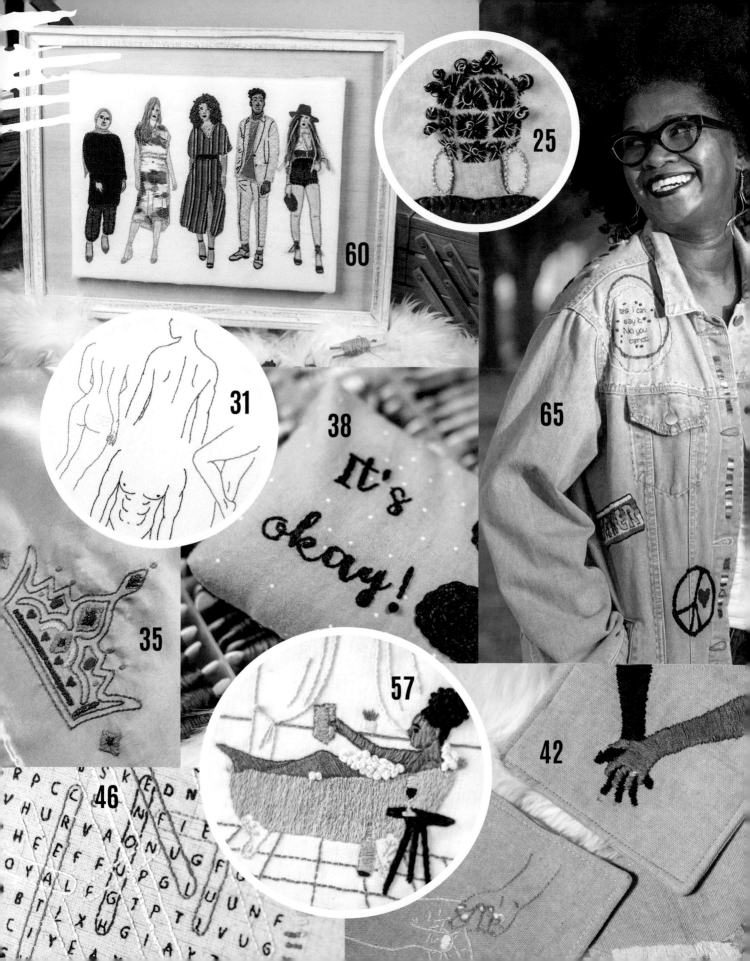

60

25

31

38

65

35

57

42

46

Introduction

I first learned hand embroidery in an elementary school arts and crafts class. I loved that I could draw with a needle and thread without the need for complicated tools. Once I understood the foundational skills, I enjoyed working on something without adult supervision. I enjoyed adding embellishments to decorations for my bedroom, clothing, and accessories. As I grew, my interest turned to machine sewing and other hobbies.

While expecting my first child, I had a complicated pregnancy and was prescribed ten weeks of mandatory bed rest. To keep my mind and hands busy while my body rested, I decided to return to hand embroidery. I loved the idea of adding adorable touches to clothes and accessories for our new arrival. Due to my immobilization, I ordered highly rated embroidery books and supplies online and had them delivered to me. I noted that the main characters in these books were White with very little representation of any other racial group. Additionally, I thought the projects lacked substance and were more traditional than I like. I attributed these issues to the specific authors of the books I had bought. With nowhere to go, I decided to modify the images to show my reality more accurately. I adjusted the facial features, tweaked the hairstyles, and adjusted hair texture with realistic fibers. Lastly, I modified the illustrated messages to reflect values that are significant to me.

Using embroidery during that difficult time helped me remain creative and allowed me an opportunity to make keepsakes for my daughter. As a new mother to my daughter, and later, a son, embroidery was no longer a primary creative outlet taking a back seat to machine sewing. Years later, I was again incapacitated and relegated to eight weeks of bed rest for recovery from knee surgery. Before the procedure, I bought new embroidery books by the same and different

authors. To my vexation, the same problem persisted with the lack of racial diversity and mundane projects. Instead of modifying those designs, I returned the books and decided to start from scratch and stitch my own designs.

I saw the need for more inclusive embroidery designs, and I knew others felt the same way. At a sewing and quilting industry event, I had the opportunity to meet representatives from C&T Publishing. I shared my concerns and frustrations with current embroidery books, and I challenged them to make changes. They, in turn, challenged me to help fill the void.

Represent! Embroidery is a small step toward increasing author and content diversity in this craft. Does it bridge the vast chasm of identity groups that are underrepresented in mainstream craft? Absolutely not. This book barely touches all of the significant aspects of my identity. It is, however, a step forward, and I hope it will usher in similar books with an increasingly wider scope.

This book is an affirmation for those of us who have felt unseen in spaces occupied by everyone else. This book is for everyone who wants to stitch something a bit different than what has been offered. This book is for those who want to see themselves reflected in their art and celebrate their unique beauty. This book is for those who appreciate and value the importance of appropriately representing groups to which they do not belong. Stitch them to put yourself in the place of another and examine their experience. Stitch them to normalize and embrace the perspectives of others. The designs and projects here are fun, fresh, and will teach you skills that add color, depth and texture to your embroidery.

Getting Started

SUPPLIES

EMBROIDERY TOOL KIT

- Embroidery hoops in various sizes
- Embroidery needles
- Embroidery floss
- Perle cotton
- Fabric
- Stabilizer
- Iron
- Ironing board
- Needle threader
- Non-permanent fabric marker
- Pincushion
- Scissors
- Thimble
- Wash Away Stitch Stabilizer (by C&T Publishing)
- 32-pack of Crayola Colors of the World Crayons

FABRIC CHOICES

Fabric options for embroidery are vast. As a rule of thumb, if the needle can easily pass through it and it will hold up to the weight of the finished embroidery, it's a good choice.

- Plain or printed cotton
- Tight-weave linen
- Satin
- Canvas
- Denim
- Sheer voile
- Cork
- Felt
- Ready to wear garments like shirts, jackets, sweatshirts and hats

FLOSS AND OTHER FIBERS

Embroidery floss is sold in bundles, skeins, and spools in a wide range of colors. Each length of floss is made up of six interlocking strands. You can stitch with all six strands or separate the floss into smaller combinations for thicker or thinner detail work.

To show density and texture in designs, you can use handspun yarn, crochet thread, and standard acrylic yarn. These fibers are usually a single strand of thicker fibers.

The projects in this book are stitched with fibers sourced from estate sales, thrift stores, and purchased over time. I am a firm believer of using what I have on hand. I have used DMC and Artiste embroidery floss, perle cotton, and crochet thread as well as Lion Brand Landscapes yarn.

NEEDLES

There are an assortment of embroidery and crewel needles with different eye sizes and lengths. I purchased an assortment of needles that can accommodate single strands of embroidery floss or larger, thicker fibers.

MARKING TOOLS

The designs for the projects are on reusable iron-on transfer pages, but there are more designs that you can trace in the Embroidery Design Gallery (page 69). If you want to use an iron-on design in a different size or modify it in other ways, you can isolate and trace the elements to stitch. To transfer your modified design to the background fabric or use an image from the gallery, use wash-away or disappearing marking tools. See Transferring Designs (page 11).

CARDSTOCK

I use cardstock to help finish the backs of my embroidery projects. It provides a stable backing to hide the back threads of a project. It also serves as a project marker where I can record the title, date, and stitcher of the project.

STABILIZERS

When embroidering on stretch, slippery, or delicate fabrics, you may need to apply a fusible fabric stabilizer to the back side of the fabric. Choose a wash-away type if using a sheer fabric where the

The fabric on the right has stabilizer applied after coloring. The fabric on the left was colored after applying fusible stabilizer.

transparency needs to be preserved. If long-term stability is a priority, consider using a permanent stabilizer.

Another benefit of using fusible stabilizer is that it can help you bring a realistic look to skin texture. When applied to the back side of the fabric before crayon tinting, fusible stabilizer adds dimension to the look of skin. When applied to the fabric after crayon tinting, it does not impact the look of the fabric.

MAGNETIC PINCUSHION

A magnetic needle minder or magnetic pincushion secures needles when not in use. It is also handy for locating a dropped or misplaced needle.

NEEDLE THREADER

This tool helps with threading small strands of floss and bulkier fibers. It is a wonderful time-saver, which helps reduce frustration. A sturdy wire variety works best for working heavy fibers. I have found that those readily available are too weak for the denser fibers I use. I make my own with 26-gauge floral wire. Cut a length about 4″ (10.2cm), fold in half to create a loop, and twist the ends together.

To use, pass the wire loop through the eye of the needle. Then pass the fiber through the wire. Pull the threader and fiber through the needle.

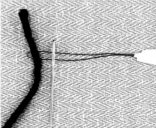

THIMBLE

Leather thimbles or rubber thread pullers help protect the fingers while stitching. They are great for long-term projects or when stitching through dense fabrics like cork or denim. Even if the stitches can be worked without a thimble, I suggest you use one. Over time, working without a thimble may result in hand fatigue, and the integrity of your work may suffer.

MACHINE SEWING TOOL KIT

- Fabric marking tools
- Iron
- Ironing board and press cloth
- Acrylic ruler to help make straight cuts
- Seam ripper
- General purpose thread
- Dressmaking scissors (for fabric cutting)
- Embroidery scissors
- Craft scissors (for paper cutting)
- Straight pins and a pin cushion
- Pattern weights (for keeping patterns and fabric in place for tracing pinning and cutting)
- Hand sewing needles
- Tape measure
- Point turner or chopstick (help push out corners for the projects)
- Fabric clips (to secure fabrics where pinning would leave marks or damage the fabric)
- Rotary cutter and self-healing mat (to quickly cut out fabric with pins or weights)
- Sewing machine with a general purpose foot and a zipper foot

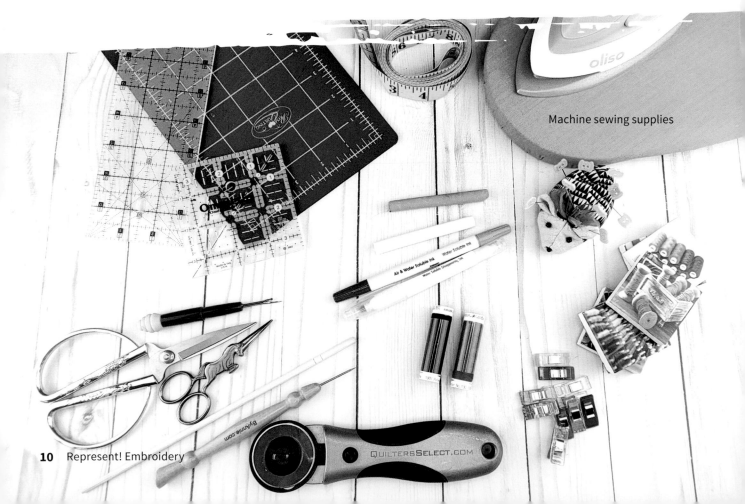

Machine sewing supplies

Techniques

TRANSFERRING PATTERNS

This book includes hot iron transfers for fast and easy transfer of images onto the fabric and also offers alternative designs in the Embroidery Design Gallery (page 69).

Note that the iron-on designs are reversed so they will print correctly on the top of your background fabric. If you are tracing the iron-on designs instead of ironing them on, trace them from the back so they will be oriented correctly. The designs in the Embroidery Design Gallery are meant to be traced and so are not reversed. These can be traced as is.

IRON-ON TRANSFERS

Test a sample before transferring the complete motif to the final fabric. These transfers are reusable and can be printed multiple times on various fabrics until the ink has been exhausted. After that, they can be copied and traced for continued use of the design.

1 Cut the design out of the transfer paper. Heat iron on a medium setting with no steam.

2 Position the transfer face down on your fabric. Use a pin to secure the paper and fabric to prevent shifting.

3 Apply the hot iron to the transfer paper and hold in place for a few seconds. Do not rub the iron over the surface of the fabric. Instead, set the iron down and raise it up to apply the heat.

4 Check the fabric and apply more heat if necessary. The length of time for the image to transfer depends on the fabric choice, iron temperature, and number of times the image has been used.

WASH-AWAY STITCH STABILIZER

1 Print, copy, or trace the design directly onto the top side of the sheet.

2 Remove the paper backing and adhere it to the fabric.

3 Stitch through the design.

4 Once the embroidery is complete, unhoop the project, dissolve the stabilizer away in water, dry, and rehoop or use in your final project.

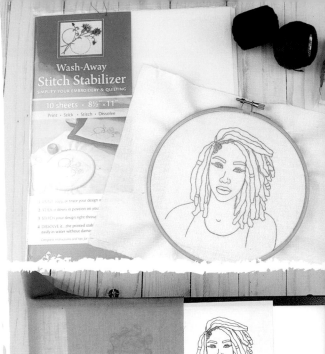

LIGHTBOX OR WINDOW TRACING

1 Place a piece of the background fabric over the design and tape it in place.

2 Secure the fabric to the light box or a window with sunlight streaming through.

3 Use a disappearing or wash-away pen with a fine tip to trace the design onto the fabric.

If you are using a new marking tool, test it on the corner of the fabric before applying it to the completed project to get an idea of how long it takes for it to disappear or how well it washes out.

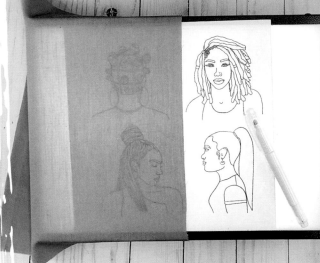

CRAYON TINTING

1 Transfer the design to the fabric. If you want the texture of the interfacing on the design, apply fusible interfacing to the wrong side of the fabric (page 9).

2 Secure the fabric in the hoop.

3 Begin by coloring along the outer edges of the image. For added dimension, apply the color darker along the edges and lighter as you move inward. Apply the color in light, even layers to get the desired density of color.

4 Once the design is colored, remove it from the hoop. Press on high with a press cloth or paper towel to set the color and remove the excess wax.

5 Rehoop the design and continue to embroider the design.

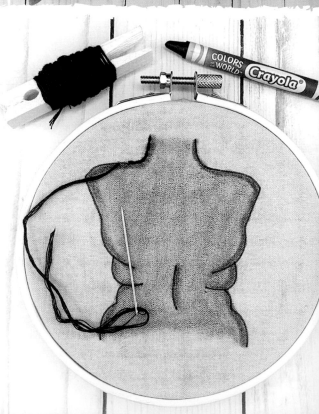

FABRIC APPLIQUÉS

Fabric elements are added with fusible web. When working with fusible web, people often trace the reversed appliqué onto the paper side of the web, fuse that to the back of the fabric, and cut the shape out from there. But I like to see the fabric to get my placement right, so I do things a little differently to work from the front.

1 Copy or trace the design onto your fabric. Cut the design element you want to use and leave a perimeter beyond the design. You may need a utility knife to remove smaller detailed areas.

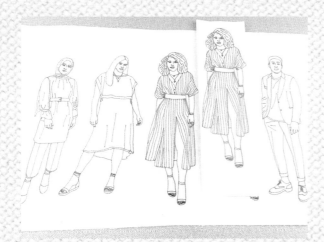

2 Fuse paper-backed fusible web to the back side of the fabric.

3 Cut the element from the fused fabric.

4 Remove the paper and backing and iron the appliqué in place over the design.

5 Use a blanket stitch around the perimeter of the element to secure it in place.

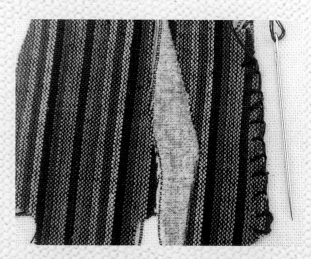

FINISHING

PRESS

Remove the wrinkles from your embroidery piece after stitching. Lay the piece face down on a towel with a high pile so it doesn't crush the design. With the steam function on, lower and lift the iron on the back of the work until the wrinkles are gone. Insert the piece into an embroidery hoop, frame, or whatever display item you are using.

HOOP FINISHING

ADD CARD STOCK TO THE INNER HOOP

1 Use the inner hoop as a pattern to trace a circle from card stock. Cut it out.

2 Insert the card stock circle to the back side of the design.

3 Trim the excess fabric behind the hoop, leaving about 2″ (5.1cm) of extra fabric beyond the hoop.

4 Thread a needle with sewing thread and knot the end. Sew a running stitch around the edge of the fabric, gathering the fabric as you stitch. At the end, secure the threads in a knot. *fig. A*

FINISH THE BACK OF THE OUTER HOOP

1 Use the outer hoop as a pattern to trace a circle from card stock. Cut it out.

2 Follow steps 2 and 3 for adding card stock to the inner hoop.

3 Apply glue to the edge of the outer hoop. Place the cardstock over the glue. *fig. B*

Use the same technique to finish the back of canvas frames.

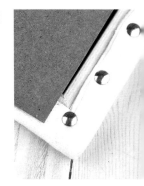

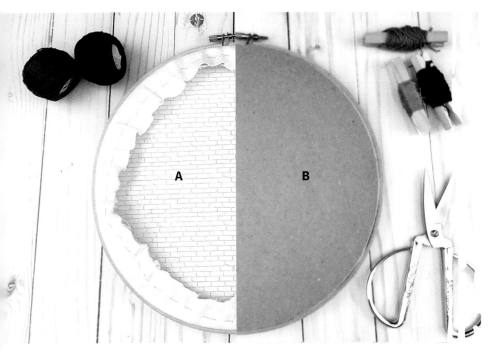

METRIC CONVERSIONS

The metric measurements in this book follow standard conversion practices for sewing and soft crafts. The metric equivalents are often rounded off for ease of use. If you need more exact measurements, there are a number of amazing online converters.

Stitching

BEFORE YOU STITCH

PREPARE THE FABRIC

1 Prewash and iron the base fabric.

2 If the fabric requires stabilization to prevent it from stretching while stitching, apply it now. Fuse stabilizer to the wrong side of the fabric.

3 Transfer the design to the right side of the fabric and begin stitching.

4 Stitch through the stabilizer and the fabric. Remove the stabilizer per product instructions or allow it to remain in place, if permanent.

HOOP THE FABRIC

1 Secure the fabric into the hoop by stretching it over the smaller internal hoop. Place the larger external hoop over the fabric and internal hoop with the fabric in between.

2 Adjust the tightness of the hoop using the screw at the top. The fabric should be drum tight without causing the hoop to warp or bend.

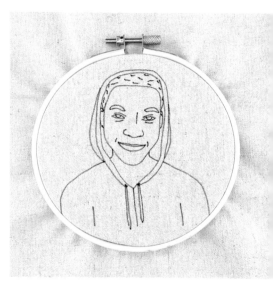

Hoop burn is the impression of the embroidery hoop on the fabric if it is screwed too tight. Avoid this by not over tightening in the hoop or by removing fabric from the hoop when not stitching. To remove hoop burn, spray the marks with plain water, let dry, and press marks with a steam iron.

THREAD THE NEEDLE

1 Thread the needle with a length of floss that is approximately the length of the wrist to the elbow. Use a needle threader to aid this process.

2 Tie a knot at the end of the floss by rolling it around and then off the tip of the finger, pulling it into a knot.

READING THE STITCH GUIDES

The stitch guide with each project shows the brand and color of the fiber used, followed by an abbreviation of which stitch to use. See the stitch abbreviations in Hand Embroidery How-Tos below. The number in parentheses refers to the number of strands of floss. For example:

• DMC: DMC 713 BL (3)—use 3 strands of DMC 713 for the blanket stitch.

• Artiste: ART 308 FK (6)—use 6 strands of Artiste ART 308 for the French knot.

• Lion Brand: LB RG (1)—use 1 strand of Lion Brand LB for the running stitch.

HAND EMBROIDERY HOW-TOS

BLANKET STITCH (BL)

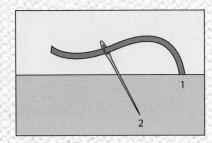 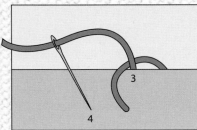 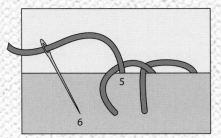

BACKSTITCH (BK)

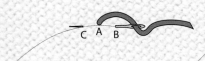

CHAIN STITCH (CH) FRENCH KNOT (FK)

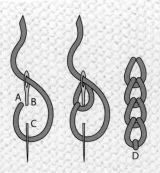 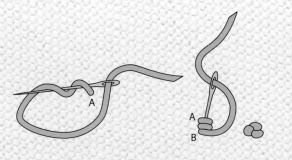

LONG SHORT STITCH (LS)

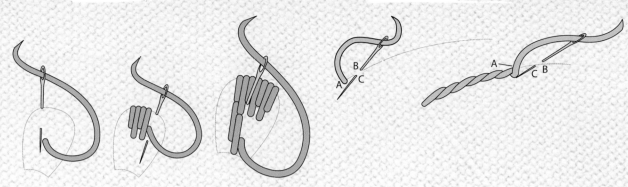

OUTLINE / STEM STITCH (OS)

RAISED SATIN STITCH (RS)

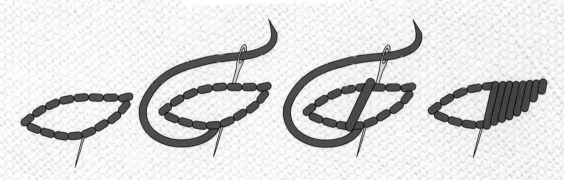

RUNNING STITCH (RG)

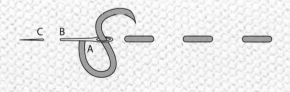

SATIN STITCH (ST)

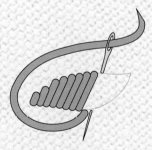

SLIP STITCH (SL)

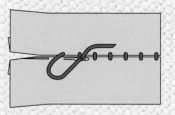

SPLIT STITCH (SP)

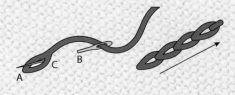

STRAIGHT STITCH (SS)

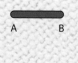

A B

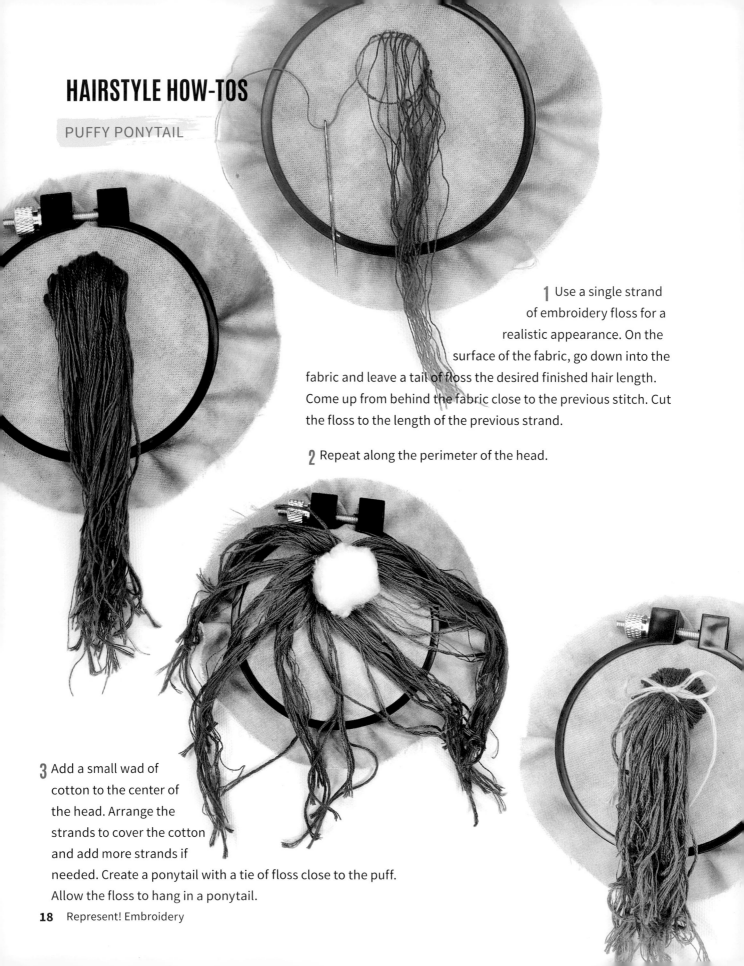

HAIRSTYLE HOW-TOS

PUFFY PONYTAIL

1 Use a single strand of embroidery floss for a realistic appearance. On the surface of the fabric, go down into the fabric and leave a tail of floss the desired finished hair length. Come up from behind the fabric close to the previous stitch. Cut the floss to the length of the previous strand.

2 Repeat along the perimeter of the head.

3 Add a small wad of cotton to the center of the head. Arrange the strands to cover the cotton and add more strands if needed. Create a ponytail with a tie of floss close to the puff. Allow the floss to hang in a ponytail.

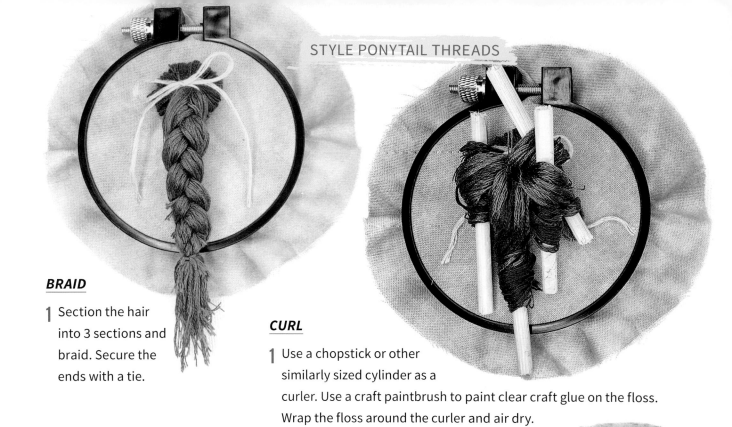

BRAID

1 Section the hair into 3 sections and braid. Secure the ends with a tie.

CURL

1 Use a chopstick or other similarly sized cylinder as a curler. Use a craft paintbrush to paint clear craft glue on the floss. Wrap the floss around the curler and air dry.

2 Unwrap and fluff.

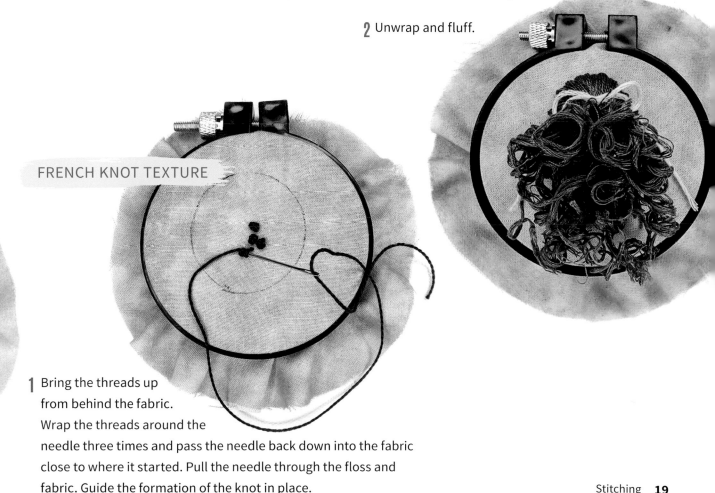

FRENCH KNOT TEXTURE

1 Bring the threads up from behind the fabric. Wrap the threads around the needle three times and pass the needle back down into the fabric close to where it started. Pull the needle through the floss and fabric. Guide the formation of the knot in place.

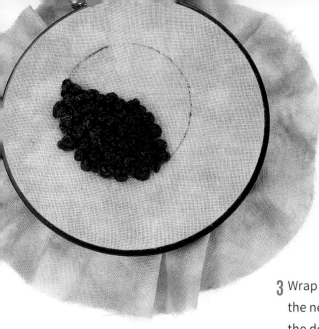

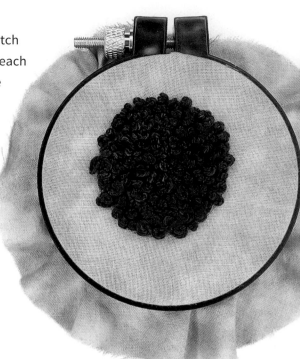

2 Continue to stitch knots close to each other to fill the design area.

3 Wrap the floss around the needle to achieve the desired fullness.

FULL LOOPED TEXTURE

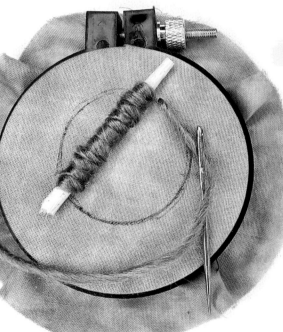

1 Use a chopstick or another similarly sized cylinder as a curler. Bring the floss up from behind the fabric. Lay the curler on the fabric and stitch over it. Bring the thread up from behind the fabric close to the previous stitch.

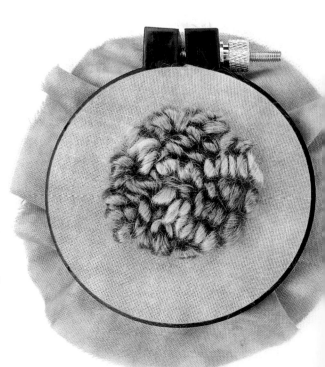

2 Continue to stitch over the curler on the design. Knot the fiber on the back side of the fabric. Remove the curler and reposition it over another area of the design to create another curl. Keep repositioning and stitching until complete.

3 Try different sized cylinders, toothpicks, straws, or pencils to achieve different textures. Use different fibers to achieve a different volume or fullness.

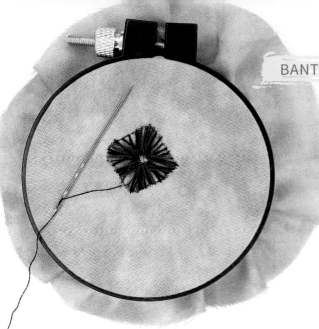

BANTU KNOTS

1 Use a single strand of embroidery floss for the base of the design. Stitch a single stitch from the edge of the design to the center. Bring the floss up from the center and return it next to the edge of the previous stitch.

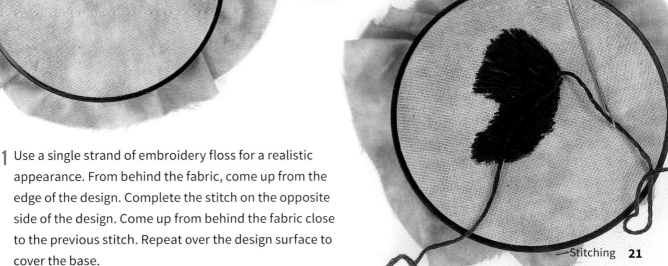

2 Repeat around the entire design. Use the full 6 strands to add a French Knot in the center of the design.

3 Bring the floss up from behind, close to the knot. Wrap the floss around the base of the French knot to achieve the desired fullness.

4 Bring the floss down close to the knot and secure on the underside of the fabric.

SMOOTH PONYTAIL

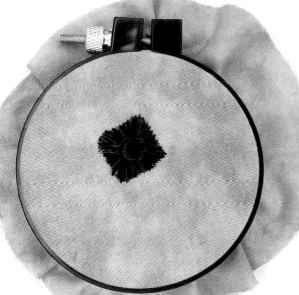

1 Use a single strand of embroidery floss for a realistic appearance. From behind the fabric, come up from the edge of the design. Complete the stitch on the opposite side of the design. Come up from behind the fabric close to the previous stitch. Repeat over the design surface to cover the base.

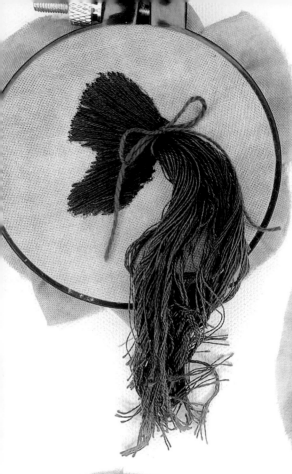

2 Use the full 6 strands to create the ponytail. On the surface of the fabric, go down into the fabric and leave a tail of floss the desired finished ponytail length. Come up from behind the fabric close to the previous stitch. Cut the floss to the length of the previous strand. Repeat to get to the desired fullness.

3 Style.

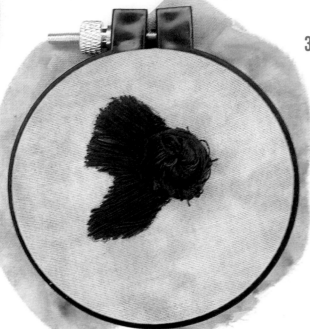

BOX BRAIDS

1 Begin as you would with Bantu knots. Use a single strand of embroidery floss for the base of the design. Stitch a single stitch from the edge of the design to the center. Bring the floss up from the center and return it next to the edge of the previous stitch.

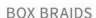

2 Use the full 6 strands of floss. On the surface of the fabric, go down into the fabric and leave a tail of floss the desired finished ponytail length. Come up from behind the fabric close to the previous stitch. Cut the floss to the length of the previous strand. Repeat to get to the desired fullness.

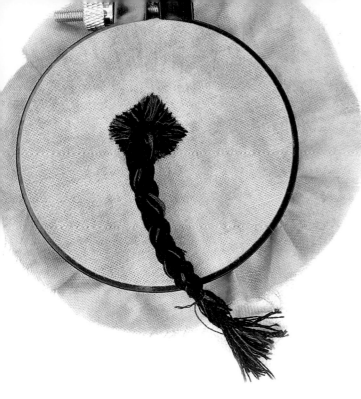

3 Section the hair into 3 sections and braid. Secure the ends with a tie.

FREE PLAITS

1 Thread the needle with your fiber of choice. (I used medium size 4 yarn.)

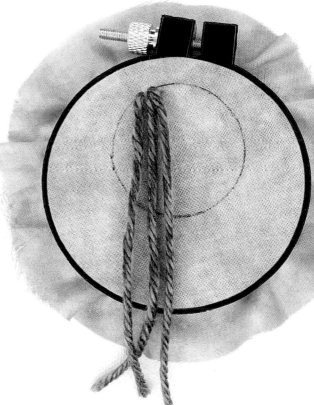

2 Come down on the right side of the fabric with an unknotted tail on the surface of the fabric. Come up from behind the fabric close to the previous stitch.

3 Cut the yarn to the length of the previous strand to create 2 of the 3 braid strands. Come up under the previous stitches with the third strand.

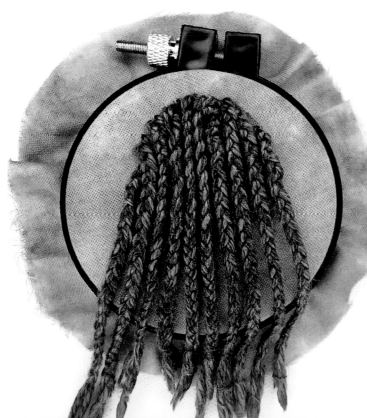

4 Cut the strand to the length of the previous strands. Braid yarn and tie the ends with a length of floss. Continue adding and braiding the yarn until the head is covered.

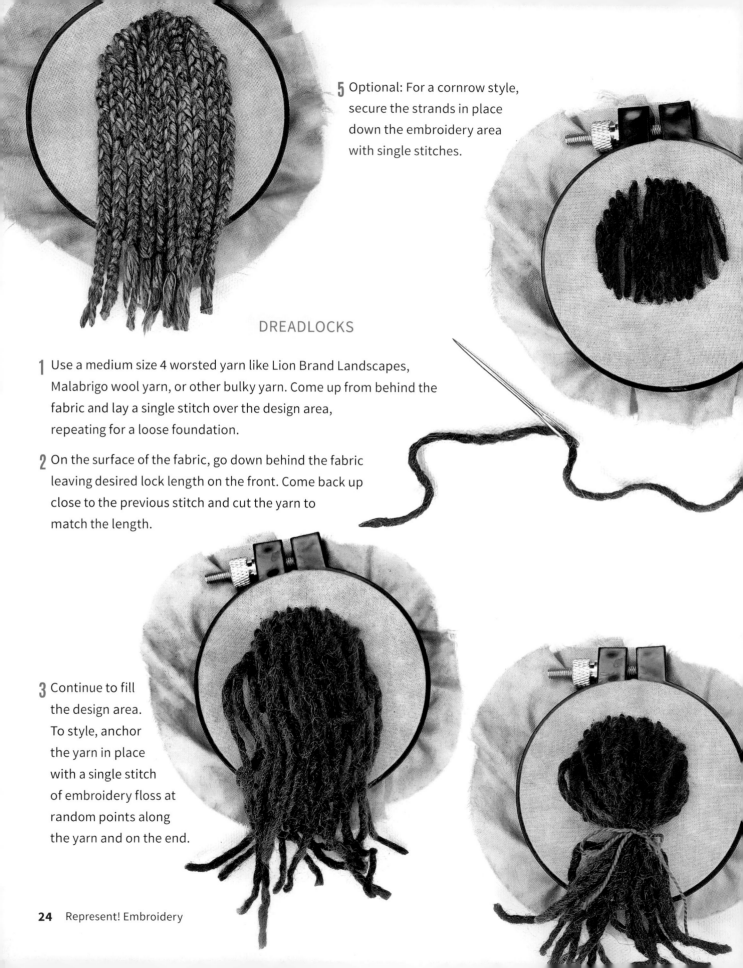

5 Optional: For a cornrow style, secure the strands in place down the embroidery area with single stitches.

DREADLOCKS

1 Use a medium size 4 worsted yarn like Lion Brand Landscapes, Malabrigo wool yarn, or other bulky yarn. Come up from behind the fabric and lay a single stitch over the design area, repeating for a loose foundation.

2 On the surface of the fabric, go down behind the fabric leaving desired lock length on the front. Come back up close to the previous stitch and cut the yarn to match the length.

3 Continue to fill the design area. To style, anchor the yarn in place with a single stitch of embroidery floss at random points along the yarn and on the end.

WHY NOT? *natural hairstyle hoops*

Finished hoop size: 5˝ (12.7cm) in diameter

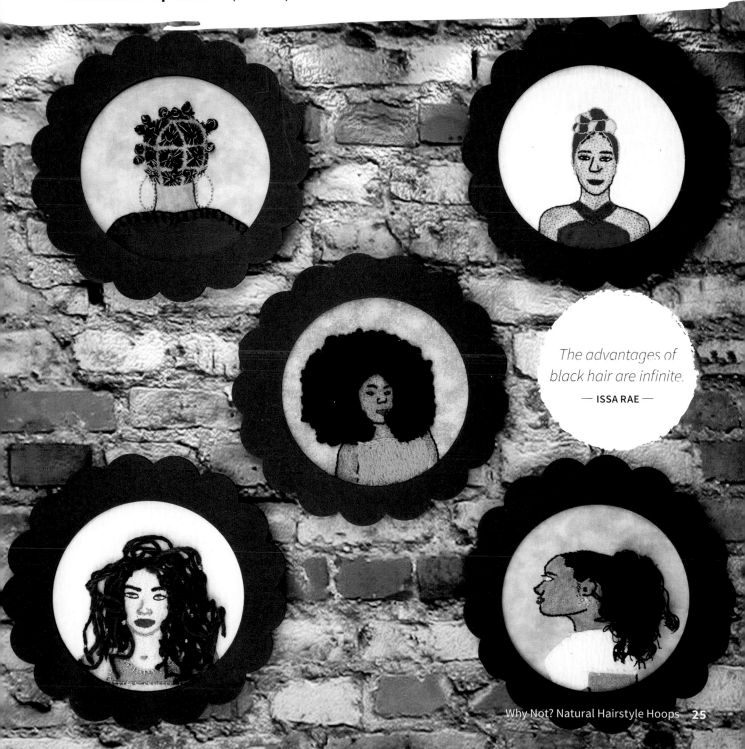

The advantages of black hair are infinite.
— ISSA RAE —

After many years of not seeing her, I recon-
nected with one of my cousins. Since the
last time I saw her, she had stopped using
chemical relaxers to straighten her hair. I
admired the beautiful fullness, increased
length, and lush texture of her gorgeous hair. When I complimented
her, she suggested I do the same. My hair routine at the time involved
chemical retouching of my natural hair as it grew and wrapping my hair
at night for a sleek look in the morning. My immediate response, without
thinking about it, was, "No, I don't think so." When she followed up with
"Why not?" I responded about the ease of my routine and not having
time to learn how to style my natural hair. She didn't push me, but that
"why not?" stuck with me for months after.

Embrace what makes you unique, even if it makes others uncomfortable. — JANELLE MONAE

You have the power to change perception, to inspire and empower, and show people how to embrace their complications, and see the flaws, and the true beauty and strength that's inside all of us. — BEYONCE

In that time, I did some self-examination to
truly drill down on my reluctance. I realized
that my "why not" was not about the ease
and convenience of straight hair. It was tied to
institutionalized oppression, systemic racism,
transgenerational transmission of trauma,
Eurocentric beauty standards, perceived
definitions of professionalism, and my desire
to not stand out negatively and radically in the
workplace.

These weighty realizations and revealed
fears did not sit well with me. I made the
choice to discontinue relaxing my hair
and to embrace the "kinky," "nappy,"
"picky" hair with which I was born. I had
just completed graduate school and was
beginning my first professional job investigating sexual harassment,
discrimination, and other EEO complaints at a major university. Unlike
many Black women in the workplace both then and now, I was in the
perfect position to begin my natural hair journey without fear of
professional repercussions.

For me, hair is an accouterment. Hair is jewelry. It's an accessory. — JILL SCOTT

There are many natural hairstyles and protective styling options to
celebrate the uniqueness of our natural hair. I enjoy creating them on
myself and our children and recreating them in fiber.

materials

Supplies for 1 hoop

NEUTRAL FABRIC: a square 8″ × 8″ (20.3 × 20.3cm) for the background

SCRAP FABRIC: for the fabric appliqués

DOUBLE-SIDED FUSIBLE WEB: for the fabric appliqués

32-PACK OF CRAYOLA COLORS OF THE WORLD CRAYONS

OPTIONAL: Embroidery hoop frames (available on my website)

FUSIBLE INTERFACING

ASSORTED EMBROIDERY FLOSS: 1 skein each of color. See the stitch guides (pages 27–29) for floss colors.

EMBROIDERY HOOP: 5″ (12.7cm)

EMBROIDERY PATTERNS (pages 97 and 99). And, see an additional variation (page 70).

INSTRUCTIONS

See Getting Started (page 8) for information on marking fabric, transferring images, finishing your hoop, and other techniques.

EMBROIDERY

1 Center the iron-on design on the top of the background fabric. Transfer the design to the fabric with a medium-hot iron. If you want to change the iron-on design or use a design from the Embroidery Design Gallery, see Transferring Patterns (page 11).

2 Color the skin areas of the design. See Crayon Tinting (page 12).

3 Make and stitch the fabric appliqués (page 13).

4 Embroider the remainder of the design. Refer to the stitch guides (pages 27–29) to see which stitch, floss color, and number of strands to use for each element of the designs.

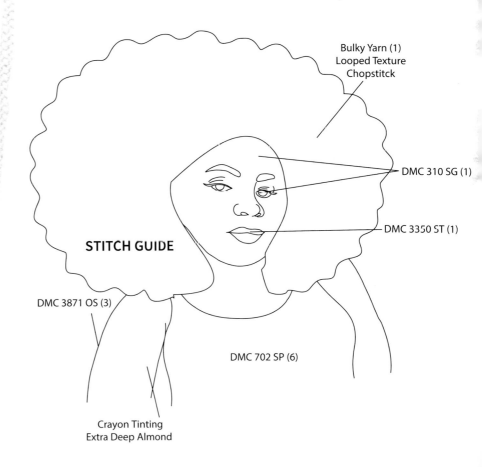

Bulky Yarn (1)
Looped Texture
Chopstitck

DMC 310 SG (1)

DMC 3350 ST (1)

STITCH GUIDE

DMC 3871 OS (3)

DMC 702 SP (6)

Crayon Tinting
Extra Deep Almond

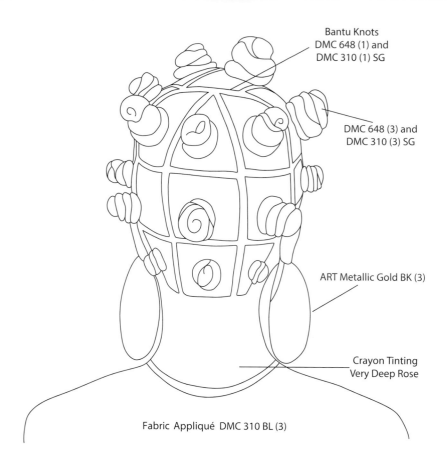

Bantu Knots
DMC 648 (1) and
DMC 310 (1) SG

DMC 648 (3) and
DMC 310 (3) SG

ART Metallic Gold BK (3)

Crayon Tinting
Very Deep Rose

Fabric Appliqué DMC 310 BL (3)

DMC 310 Smooth Ponytail with Curls (1)

DMC 3371 OS (3)

DMC 310 SG (1)

DMC 437 St (1)

STITCH GUIDES

DMC 3804 OS (3)

DMC 318 St (1)

Crayon Tinting
Extra Deep Golden

Fabric Appliqué DMC 318 BL (3)

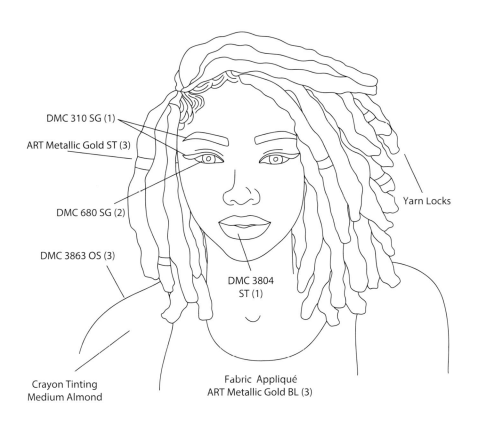

DMC 310 SG (1)

ART Metallic Gold ST (3)

DMC 680 SG (2)

DMC 3863 OS (3)

Yarn Locks

DMC 3804 ST (1)

Crayon Tinting
Medium Almond

Fabric Appliqué
ART Metallic Gold BL (3)

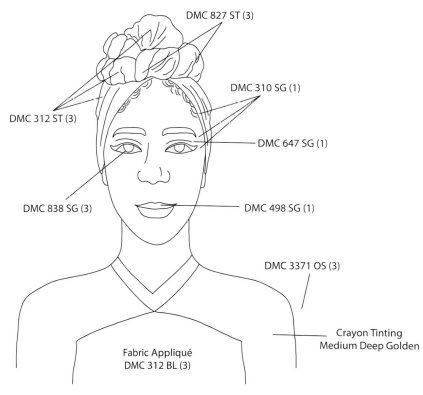

DMC 827 ST (3)

DMC 310 SG (1)

DMC 312 ST (3)

DMC 647 SG (1)

DMC 838 SG (3)

DMC 498 SG (1)

DMC 3371 OS (3)

Crayon Tinting
Medium Deep Golden

Fabric Appliqué
DMC 312 BL (3)

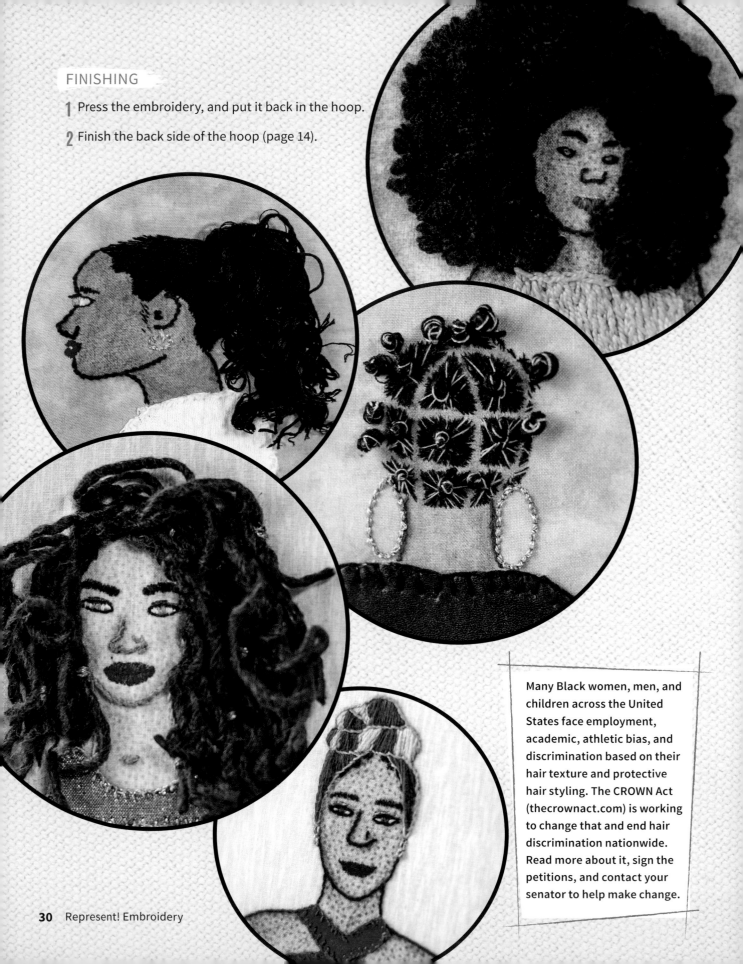

FINISHING

1 Press the embroidery, and put it back in the hoop.

2 Finish the back side of the hoop (page 14).

Many Black women, men, and children across the United States face employment, academic, athletic bias, and discrimination based on their hair texture and protective hair styling. The CROWN Act (thecrownact.com) is working to change that and end hair discrimination nationwide. Read more about it, sign the petitions, and contact your senator to help make change.

THE DEFINITION OF NUDE
hoop

Finished hoop size: 10˝ (25.4cm) diameter

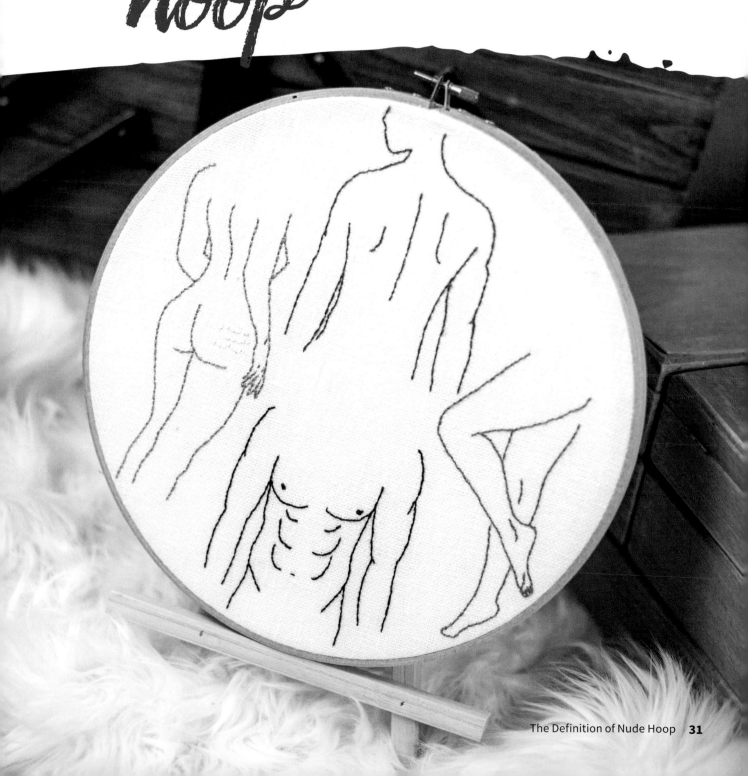

The misnomer of "nude" is widely used in the craft, fashion, beauty, and art industries to define colors referring to White skin. It prioritizes whiteness and marginalizes and excludes everyone whose skin is not white. It communicates the ideal target audience and it blatantly elevates whiteness, rendering secondary those whose skin is not white. It is ingrained, pervasive, and dismissed as normal by those

If you want to make a human being into a monster, deny them, at the cultural level, any reflection of themselves. And growing up, I felt like a monster in some ways. I didn't see myself reflected at all. I was like, 'Yo is something wrong with me? That the whole society seems to think that people like me don't exist?'
— **JUNOT DIAZ**

never hurt by its misuse. With this design, I remind, redirect, and correctly reassign "nude" to refer to a state of undress. It is a simple celebration of the naked form in various shades.

I have experienced many instances of racial bias within the sewing industry. In 2014, I confronted a couture company about the use of the misnomer of "nude" for their new collection. As a supporter of the company, I contacted them to discuss how it excluded and marginalized people of color. The owner dismissed my concerns as irrelevant and insignificant. I used my blog to begin a dialogue about the pervasive nature of systemic racism. That experience and the discussions that followed were the inspiration for a community quilt project. In 2017, my friend Hillary Goodwin enlisted contributors from around the world to lend their voice to the *Nude is Not a Color* quilt. In 2020, that quilt was acquired by The Henry Ford Museum.

To read more about the project:

thehenryford.org/explore/blog/a-quilt-with-a-cause

Here is a link to the digital collections website:

thehenryford.org/collections-and-research/digital-collections/artifact/511810

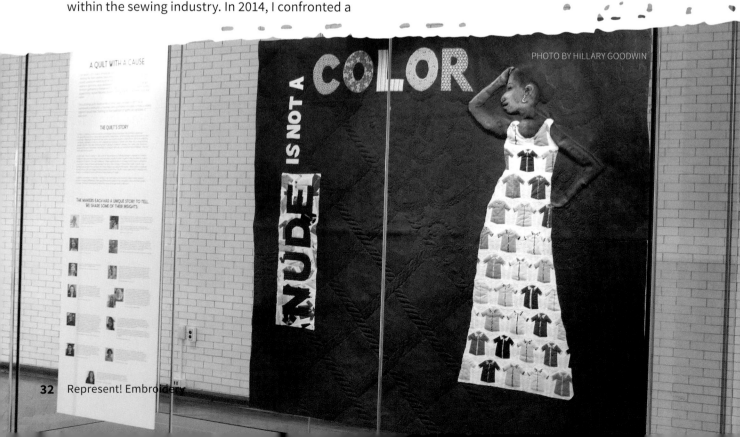

PHOTO BY HILLARY GOODWIN

materials

FABRIC: A square at least 12″ × 12″ (30.5 × 30.5cm) for the background

EMBROIDERY HOOP: 10″ (25.4cm)

ASSORTED EMBROIDERY FLOSS: 1 skein each of color. See the embroidery stitch guide below for floss colors.

ASSORTED EMBROIDERY FLOSS: 1 skein of each color

OPTIONAL: 32-pack of Crayola Colors of the World Crayons

EMBROIDERY PATTERN (page 101)

INSTRUCTIONS

See Getting Started (page 8) for information on marking fabric, transferring images, finishing your hoop, and other techniques.

EMBROIDERY

1 Center the iron-on pattern on the top of the background fabric. Transfer the design to the fabric with a medium hot iron. You will have to cut the pattern apart between the main image and the legs on the right, then position the legs in place as shown in the project photo. If you'd like to use curvier legs in your stitching, you could substitute the curvy legs pattern (page 99).

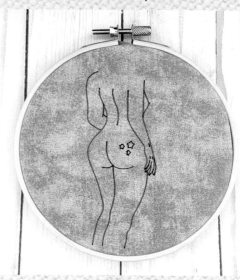

Apply lightweight fusible interfacing to the back side of your fabric if necessary. Use a marking tool to add customized body features such as freckles, stretch marks, beauty marks, body hair, and tattoos to the design.

If you want to change the iron-on design or use a design from the Embroidery Design Gallery, see Transferring Patterns (page 11).

2 Embroider the design. Refer to the stitch guide below to see which stitch, floss color, and number of strands to use for each element of the design.

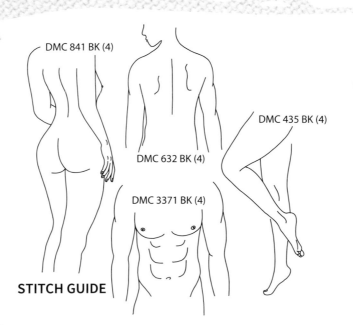

DMC 841 BK (4)

DMC 632 BK (4)

DMC 3371 BK (4)

DMC 435 BK (4)

STITCH GUIDE

FINISHING

1 Press the embroidery, and put it back in the hoop.

2 Finish the back side of the hoop (page 14).

VARIATIONS

• Transfer each design individually. Hoop and stitch them as a multiple-piece vignette in 5˝ (12.7cm) hoops.

• Transfer one design several times in a row on the same piece of fabric. Hoop and stitch each design in graduating colors to celebrate a range of skin colors or in rainbow colors to celebrate Pride.

• Use the same color fabric and embroidery floss for a monochromatic look.

• Add crayon tinting to the transferred design before stitching.

• Use the curvier legs (page 99) instead of the legs on the right side of the design.

• Or try stitching the design (page 99) using rainbow or variegated thread.

When I look in the mirror and the only one there is me. Every freckle on my face is where it's supposed to be. And I know my creator didn't make no mistakes on me. My feet my thighs, my lips, my eyes, I'm loving what I see.

— INDIA.ARIE —

PROTECT THE CROWN
pillowcase

Finished size: Standard pillowcase
20˝ × 26˝ (50.8 × 66cm)

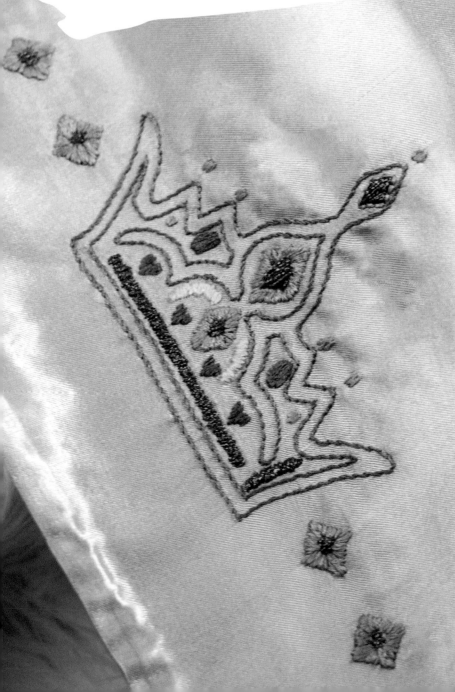

Sleeping on a satin or silk pillowcase helps to protect hair and skin. The smooth fibers help to reduce friction on the hair and skin, and to decrease the chance of frizzing and wrinkles. Standard pillowcase fabrics like woven cotton, cotton jersey, or flannel can be drying, but satin and silk allow for greater retention of hair oils. If hair has more moisture and less friction, it is likely to experience less breakage.

I love my hair because it is a reflection of my soul. It's dense, it's kinky, it's soft, it's textured, it's difficult, it's easy, and it's fun. That's why I love my hair.

— **TRACEE ELLIS ROSS**

My kids and I have long enjoyed the benefits of sleeping on satin. For many years, we used sleep bonnets made of satin to protect our hair. Several times a week, there were frantic searches before bedtime for the sleep bonnet misplaced in the morning rush. Frustrated with sacrificing my bonnet to one of the kids, I decided we all needed a bigger, harder-to-misplace option. I chose to upgrade purchased pillowcases with embroidery. The luxurious fabric and regal motif aids a beautiful night of sleep.

materials

STANDARD SILK OR SATIN PILLOWCASE: 1

FUSIBLE WASH-AWAY STABILIZER

FABRIC CLIPS: To keep the fabric from getting in the way while stitching.

ASSORTED EMBROIDERY FLOSS: 1 skein of each color. See the embroidery stitch guide (page 37) for floss colors.

EMBROIDERY HOOP: 10″ (25.4cm)

EMBROIDERY PATTERN (page 103). See alternate crown designs (pages 70–72).

INSTRUCTIONS

See Getting Started (page 8) for information on marking fabric, transferring images, finishing your hoop, and other techniques.

EMBROIDERY

1 Center the crown design on the opening of the pillowcase. Transfer the design to the fabric with a medium-hot iron. If you want to change the

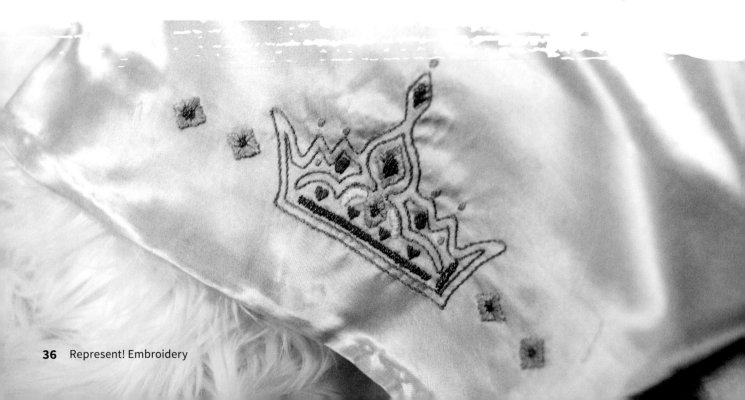

iron-on design or use a design from the Embroidery Design Gallery, see Transferring Patterns (page 11).

2 On the wrong side of the pillowcase, apply wash-away stabilizer behind the embroidery field. This gives support to the slippery fabric and prevents shifting in the hoop.

3 Secure the fabric in the hoop. Use fabric clips to hold the fabric out of the way while you stitch.

4 Embroider the design. Refer to the stitch guide below to see which stitch, floss color, and number of strands to use for each element of the design.

FINISHING

1 Remove from the hoop. Wash the stabilizer out according to product instructions. Air-dry and press on low.

VARIATION

Use the various crown designs (pages 70–72) to create an assorted border.

STITCH GUIDE

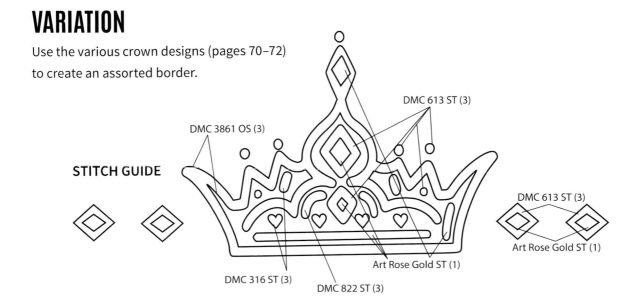

DMC 3861 OS (3)

DMC 613 ST (3)

DMC 613 ST (3)

Art Rose Gold ST (1)

Art Rose Gold ST (1)

DMC 316 ST (3)

DMC 822 ST (3)

IT'S OKAY TO NOT BE OKAY *pincushion*

Finished size: 6″ × 4″ × 2″
(15.2 × 10.2 × 5.1 cm)

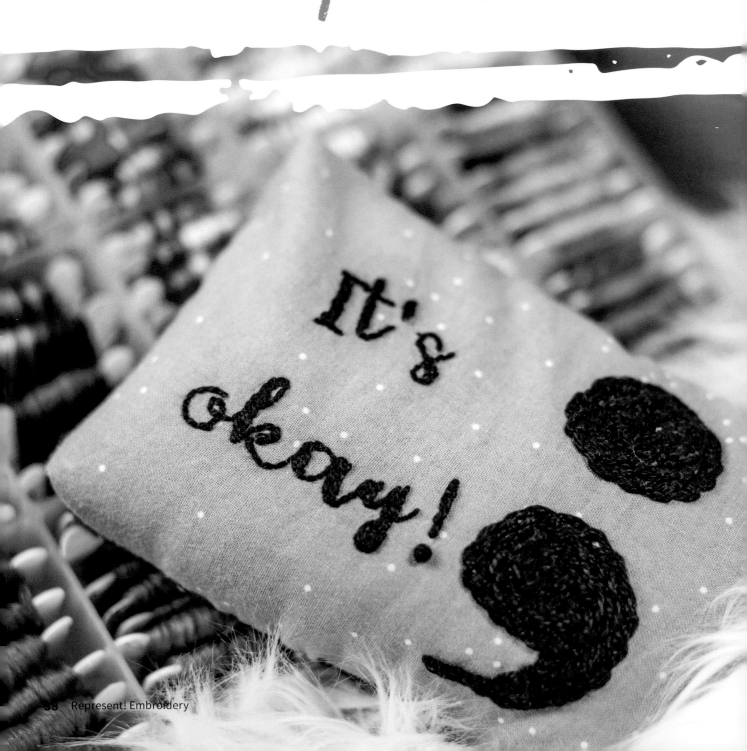

Within the craft, specifically the sewing community, there is ongoing talk about the therapeutic benefits of making. Through various physical, mental, and societal struggles in my life, I have relied on creativity to process, channel, and distract from negative emotions. Often it has helped temporarily, but it has been insufficient to resolve the root causes of the problem. Sewing is therapeutic, but it's not a substitute for therapy. It is not a substitute for acknowledging that I am not okay and in need of support. I cannot do it on my own and I don't have to.

The semicolon is a symbol of mental health awareness and suicide prevention. It symbolizes a continuation for those who struggle against suicide, depression, addiction, and other mental health issues. It communicates a promise that there is more to come, and more after.

This pincushion project is a reminder that life will stick at you. When you are not okay, it's okay to ask for help.

materials

MAIN FABRIC: a square 8″ × 8″ (20.3 × 20.3cm) for the top and a rectangle 7″ × 5″ (17.8 × 12.7cm) for the bottom

LINING FABRIC: 2 rectangles 7″ × 5″ (17.8 × 12.7cm)

MACHINE SEWING SUPPLIES (page 10)

EMBROIDERY FLOSS: 1 skein DMC perle cotton 310

EMBROIDERY HOOP: 6″ (15.2cm)

FILLER CRUSHED WALNUT SHELLS OR PLAYGROUND SAND: Approximately 3 cups (Walnut shells are available as lizard cage filler at pet supply stores). They provide good weight and sharpen the tips of the pins with use.

SMALL FUNNEL

EMBROIDERY PATTERN (page 125)

INSTRUCTIONS

See Getting Started (page 8) for information on marking fabric, transferring images, finishing your hoop, and other techniques.

EMBROIDERY

1 Center the iron-on pattern on the fabric. Transfer the pattern to the fabric with a medium hot iron. If you want to change the iron-on design or use a design from the Embroidery Design Gallery, see Transferring Patterns (page 11).

2 Embroider the design. Refer to the stitch guide (page 40) to see which stitch to use for each element of the design. (The designs are stitched with 1 strand.)

I chose a backstitch for the text to symbolize the double strength of taking a step back, then moving forward. I chose a chain stitch for the semi-colon as a reminder that we are all linked and strengthened by the connection to others.

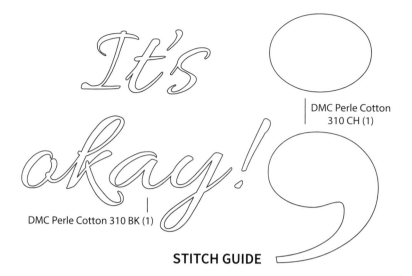

DMC Perle Cotton 310 CH (1)

DMC Perle Cotton 310 BK (1)

STITCH GUIDE

SEWING

Use ¼″ (6mm) seams.

1 Trim the main top fabric to 7″ × 5″ (17.8 × 12.7cm) to match the sizes of the back and lining pieces.

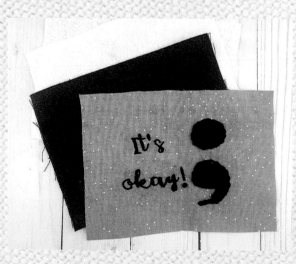

2 With right sides together and raw edges even, pin the main top fabric to the main back fabric. Stitch around the perimeter, leaving a 3″ (7.6cm) opening for turning.

3 Pull the corner seams of the top and bottom fabrics together to create a point.

4 On 1 corner, mark 1″ (2.5cm) from the point. Stitch. Trim the seam. Repeat the process on the other corners. Turn the pincushion right side out. Use a chopstick or similar blunt tool to gently poke out the corners.

5 Repeat Steps 3 and 4 on the lining fabric. Leave the wrong side out.

6 Insert the lining into the pincushion, aligning the openings.

7 Insert the funnel into the lining and fill with the crushed walnut shells or sand.

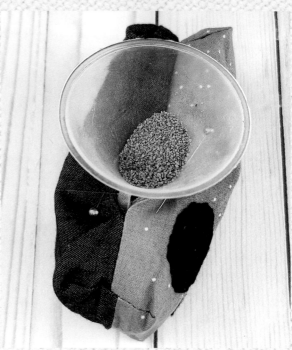

8 Slip stitch the opening in the lining closed with all-purpose thread. Repeat on the pincushion exterior.

MENTAL HEALTH RESOURCES

- **Black Mental Health Alliance** (blackmentalhealth.com)

- **National Suicide Prevention Lifeline** (suicidepreventionlifeline.org)

- **Therapy for Black Girls** (therapyforblackgirls.com)

- **National Mental Health Alliance** (NAMI.org)

- **U.S Department of Human Services** (mentalhealth.gov)

I have been in therapy for a very long time, and therapy has been crucial for me working through a lot of childhood trauma and working through a lot of my stuff. — LAVERNE COX

CONNECT OVER A CUP

coaster set

Finished size: 5″ × 5″
(12.7 × 12.7cm)

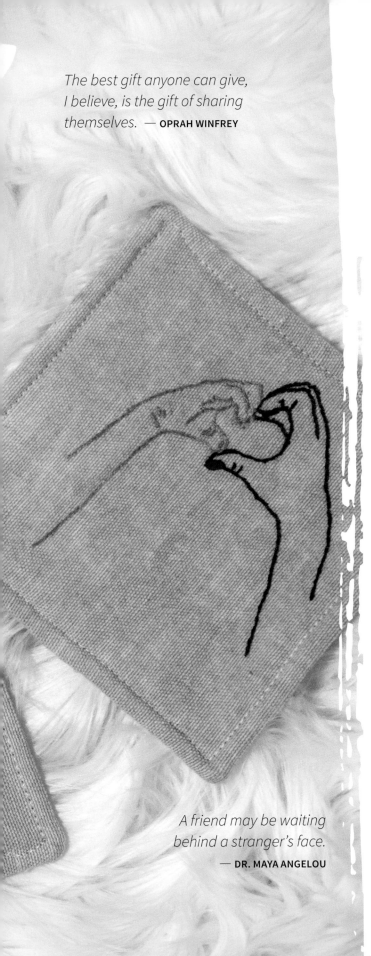

The best gift anyone can give, I believe, is the gift of sharing themselves. — **OPRAH WINFREY**

A friend may be waiting behind a stranger's face.

— **DR. MAYA ANGELOU**

There is not a more perfect way to get to know a new friend and reconnect with old ones than over a cup. These coasters are a great and fast project to highlight some important associations in life. They can represent different ages, genders, races, and relationships. They are a gentle reminder to bridge the distance, and to reach across the table to have meaningful conversations and reconnect.

materials

Supplies for one coaster

NEUTRAL FABRIC: a square 8″ × 8″ (20.3 × 20.3cm) for the top background and a square 5½″ × 5½″ (14 × 14cm) for the bottom

FUSIBLE FLEECE: a square 5½″ × 5½″ (14 × 14cm)

12-WEIGHT COTTON THREAD: 1 spool

EMBROIDERY FLOSS: 1 skein of each color

MACHINE SEWING SUPPLIES (page 10)

EMBROIDERY HOOP: 6″ (15.2cm)

EMBROIDERY PATTERNS (page 105). See 2 more examples of joined hands sized perfectly for the coasters (page 72).

INSTRUCTIONS

See Getting Started (page 8) for information on marking fabric, transferring images, finishing your hoop, and other techniques.

EMBROIDERY

1. Center each design on an 8″ (20.3cm) square. Transfer the design to the fabric with a medium hot iron. If you want to change the iron-on design or use a design from the Embroidery Design Gallery, see Transferring Patterns (page 11).

2. Embroider the design. Refer to the stitch guides (page 44) to see which stitch, floss color, and number of strands to use for each element of the design.

STITCH GUIDES

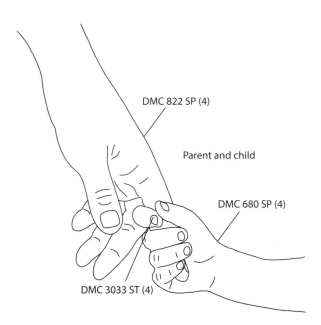

DMC 822 SP (4)

Parent and child

DMC 680 SP (4)

DMC 3033 ST (4)

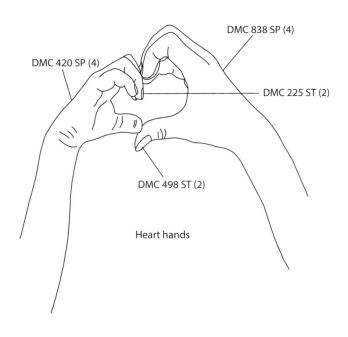

DMC 420 SP (4)

DMC 838 SP (4)

DMC 225 ST (2)

DMC 498 ST (2)

Heart hands

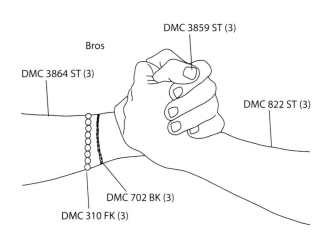

DMC 3859 ST (3)

Bros

DMC 3864 ST (3)

DMC 822 ST (3)

DMC 702 BK (3)

DMC 310 FK (3)

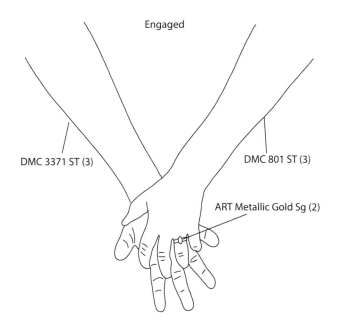

Engaged

DMC 3371 ST (3)

DMC 801 ST (3)

ART Metallic Gold Sg (2)

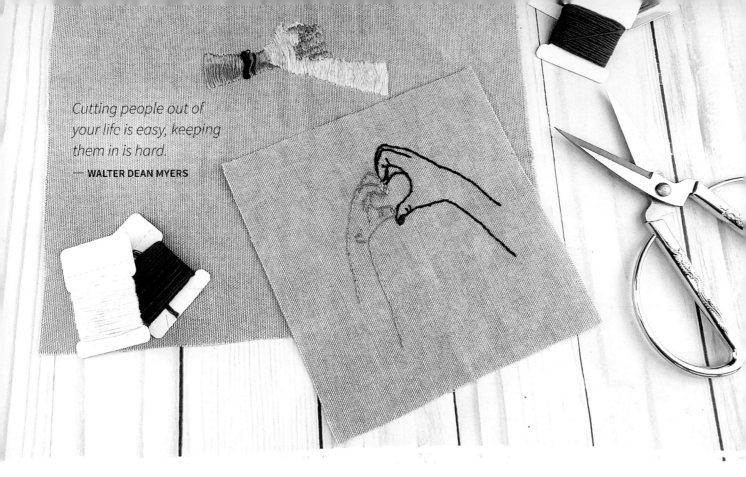

Cutting people out of your life is easy, keeping them in is hard.
— WALTER DEAN MYERS

SEWING

Use ½″ (12mm) seams.

1. Trim the embroidered top fabric to 5½″ × 5½″ (14 × 14cm) square.

2. Secure the fusible fleece to the bottom square. Fuse to wrong side of the fabric per product instructions.

3. With right sides together and raw edges even, pin the embroidered top to the bottom square. Stitch around the perimeter, leaving an opening for turning. Trim the corners.

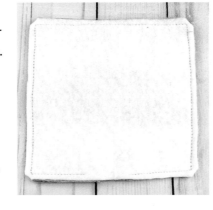

4. Turn right side out. Tuck in the seam allowance at the opening. Press.

5. Machine stitch ¼″ (6mm) from the edge around the perimeter of each coaster. This will close the opening.

VARIATIONS

- Stitch the edge of the coasters with a blanket stitch, running stitch, backstitch, or outline stitch.

- Stitch a set of coasters using a single design.

- Allow children to use fabric markers to color the designs.

- Add fabric appliqué accents to the design.

- Use cork fabric as the main fabric bottom.

FIND YOURSELF

Finished size: 11″ × 16″
(27.9 × 40.6cm)

journal cover

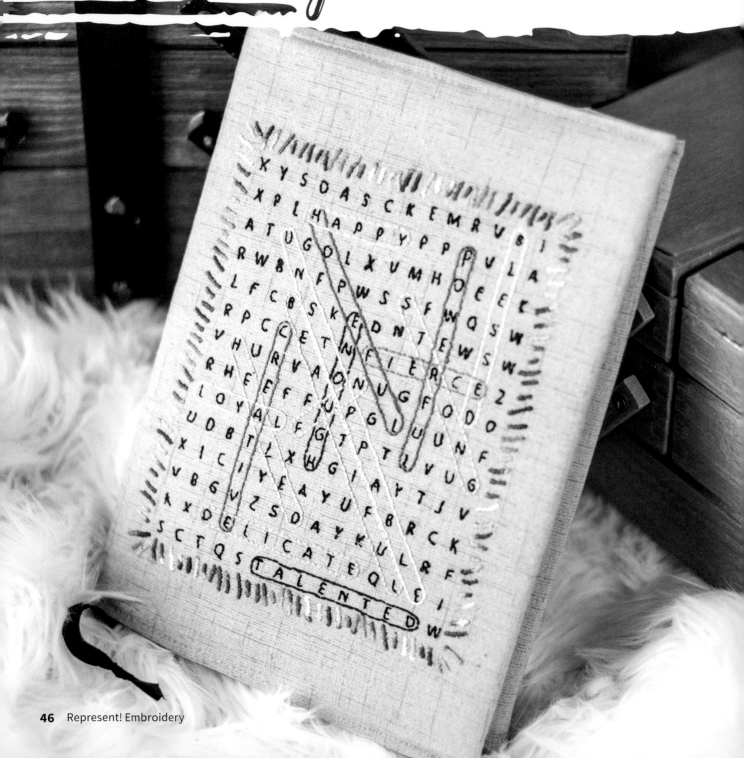

You have to decide who you are and force the world to deal with you, not with its idea of you. — JAMES BALDWIN

At every turn, there are people eager to tell you who you are, where you fit, and what you should do. The weight of labels and the expectations of others can be burdensome if you allow them to define you. Life is an ongoing journey of self-discovery, trying new things, discarding the old, and figuring out who you are; find yourself.

In the low-tech world I grew up in, I found simple joy with pen and paper while delighting myself with word search puzzles. I have brought that childhood fun here with a word search journal cover. Stitch your puzzle and find the words that resonate with you.

materials

VARIEGATED COTTON CROCHET THREAD, 12-WEIGHT: 1 spool

ASSORTED EMBROIDERY FLOSS: 1 skein each of color. See the embroidery stitch guide (page 48) for floss colors.

MAIN FABRIC FOR JOURNAL: A rectangle at least 17″ × 20″ (43.2 × 50.8cm)

LINING FABRIC: A rectangle at least 17″ × 20″ (43.2 × 50.8cm)

LIGHTWEIGHT FUSIBLE INTERFACING: a rectangle at least 17″ × 20″ (43.2 × 50.8cm)

½″ (12MM) RIBBON: 15″ length (38.1cm)

MACHINE SEWING SUPPLIES (page 10)

EMBROIDERY HOOP: 8″ (20.3cm). This is a good size hoop to stitch the small letters, but it will require repositioning to complete the design.

HARDCOVER JOURNAL: 8″ × 11″ (20.3 × 27.9cm)

Journal sizes are personal to the user. I love a big book, so this is based on my choice. The fabric requirements and image scale are based on it. The cover technique used here is not based on specific measurements and can be applied to journals of various sizes and with other images in this book.

EMBROIDERY PATTERN (page 107). See alternate word search patterns (pages 73 and 74).

INSTRUCTIONS

See Getting Started (page 8) for information on marking fabric, transferring images, finishing your hoop, and other techniques.

EMBROIDERY

1 Position the iron-on pattern 4″ (10.2cm) from the right edge and 4″ (10.2cm) down from the top and up from the bottom of the fabric. Transfer the pattern to the fabric with a medium hot iron. If you want to change the iron-on design or use a design from the Embroidery Design Gallery, see Transferring Patterns (page 11).

2 Embroider the design. Refer to the stitch guide to see which stitch, floss color, and number of strands to use for each element of the design.

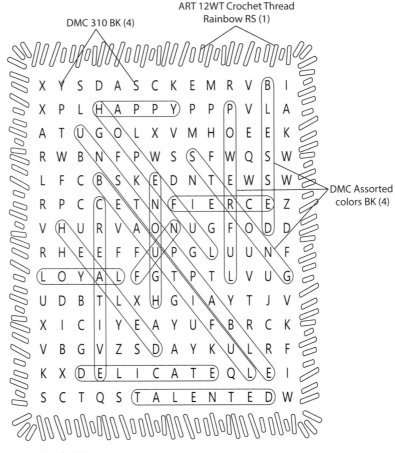

DMC 310 BK (4)

ART 12WT Crochet Thread Rainbow RS (1)

DMC Assorted colors BK (4)

X Y S D A S C K E M R V B I
X P H A P P Y P P P V L A
A T U G O L X V M H O E E K
R W B N F P W S S F W Q S W
L F C B S K E D N T E W S W
R P C C E T N F I E R C E Z
V H U R V A O N U G F O D D
R H E E F F U P G L U U N F
L O Y A L F G T P T L V U G
U D B T L X H G I A Y T J V
X I C I Y E A Y U F B R C K
V B G V Z S D A Y K U L R F
K X D E L I C A T E Q L E I
S C T Q S T A L E N T E D W

STITCH GUIDE

SEWING

Use ¼″ (6mm) seams.

1 Wrap the embroidered fabric around the journal, wrong side facing out and the embroidered design centered on the back cover. Tuck the short edges of the fabric inside the journal and chalk trace along the edge of the book to define your pattern.

2 Trim the top and bottom edges ½″ (12mm) past the chalk line. Trim the sides 2″ (5.1cm) past the chalk line.

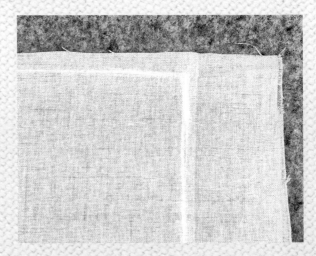

3 Use the exterior journal fabric as a pattern to cut the lining and lightweight fusible interfacing. Fuse the interfacing to the wrong side of the lining per product instructions.

4 With right sides together and raw edges even, pin the lining to the embroidered panel. Stitch the short sides. Turn right side out. Press.

5 Fold the unstitched top and bottom seam in ¼˝ (6mm).

6 Topstitch the short sides ¼˝ (6mm) from the edge.

7 Fit the cover over the journal, right side out, with the embroidered pattern at the front. Fold the short sides in to create a flap at each end, and adjust the widths to center the design. Mark the width of the flaps.

8 Mark the center top of the journal for the bookmark. Insert one end of the ribbon over the mark inside the seam and pin.

9 Remove the journal. Stitch ¼" (6mm) from the top edge of the journal to secure the flaps and ribbon bookmark. Repeat on the bottom edge to secure the bottom flaps.

10 Reinsert the journal.

VARIATIONS

• Stitch the puzzle without encircling the answers. Instead, stitch the words in a different color floss.

• Stitch the letters of the puzzle with a variegated floss. Stitch the answers in a solid floss that is not in the variegation.

• See patterns for additional puzzles and solutions (pages 73 and 74).

Helped are those who are content to be themselves; they will never lack mystery in their lives and the joys of self-discovery will be constant. —**ALICE WALKER**

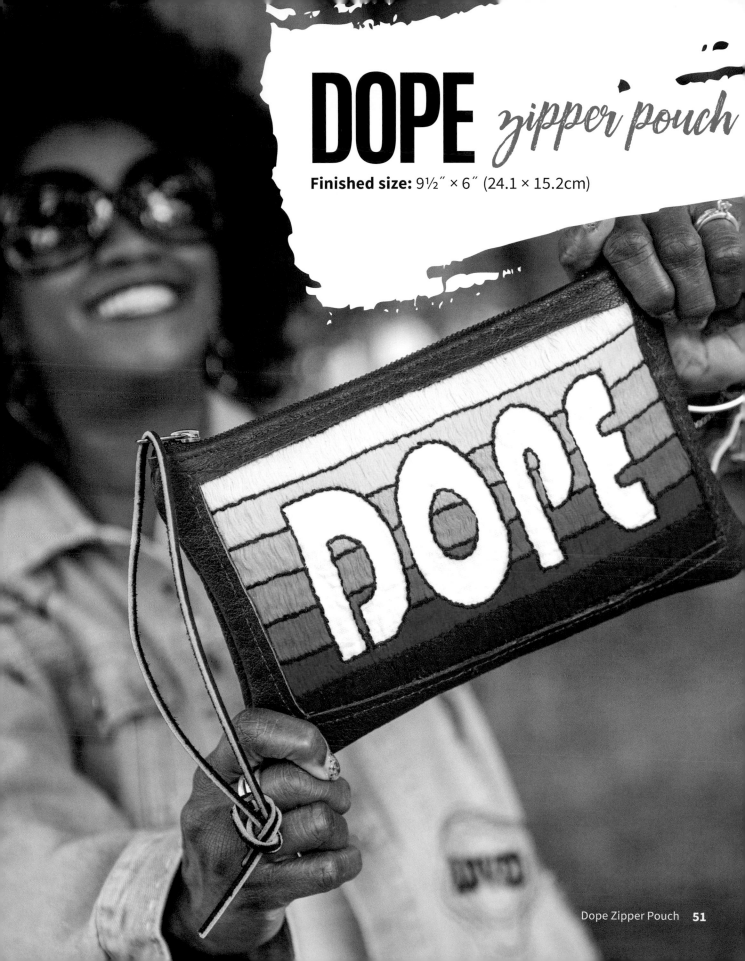

DOPE *zipper pouch*

Finished size: 9½″ × 6″ (24.1 × 15.2cm)

I love having a compact essentials pouch to carry when running errands around town. I also love to telegraph what I am about as a means to attract like-minded, creative people. This project combines a gradient stitched negative space embroidery with an everyday zipper clutch bag.

materials

NEUTRAL FABRIC: a square 14″ × 14″ (35.6 × 35.6cm) for the embroidery background

APPAREL LEATHER, CORK, PLEATHER, SYNTHETIC LEATHER OR FELT: a rectangle at least 17″ × 20″ (43.2 × 50.8cm)

FABRIC CLIPS to secure leather

LEATHER NEEDLE

COORDINATING POLYESTER THREAD for sewing leather

COORDINATING LEATHER LATIGO CORD: a length 18″ (45.7cm)

ROTARY CUTTER AND MAT for cutting leather

LINING FABRIC: a rectangle 15″ × 21″ (38.1 × 53.3cm)

LIGHTWEIGHT FUSIBLE INTERFACING: a rectangle 15″ × 21″ (38.1 × 53.3cm)

9″ (22.9CM) METAL ZIPPER: 1

BASTING TAPE OR ALL-PURPOSE FABRIC GLUE STICK

ASSORTED EMBROIDERY FLOSS: 1 skein each of color. See the embroidery stitch guide (page 53) for floss colors.

EMBROIDERY HOOP: 12″ (30.5cm)

EMBROIDERY PATTERN (page 109). See 4 more patterns drawn specifically to fit on the front of the zipper pouch (pages 90–93).

INSTRUCTIONS

See Getting Started (page 8) for information on marking fabric, transferring images, finishing your hoop, and other techniques.

EMBROIDERY

1 Center the iron-on pattern on the top of the background fabric. Transfer the design to the fabric with a medium-hot iron. If you want to change the iron-on design or use a design from the Embroidery Design Gallery, see Transferring Patterns (page 11).

2 Embroider the design. Refer to the stitch guide (page 53) to see which stitch, floss color, and number of strands to use for each element of the design.

3 Trim the embroidered design, leaving ½″ (12mm) past the design on all sides.

STITCH GUIDE

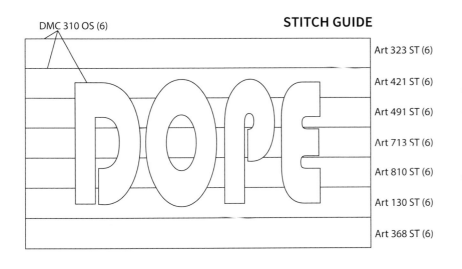

DMC 310 OS (6)

Art 323 ST (6)

Art 421 ST (6)

Art 491 ST (6)

Art 713 ST (6)

Art 810 ST (6)

Art 130 ST (6)

Art 368 ST (6)

I am the essence of magic, its mysteriousness, its beauty and its ability to make things happen when people couldn't see how!

— JENAITRE FARQUHARSON

SEWING

Use ¼″ (6mm) seams and a 4mm stitch length unless otherwise noted. Install a leather needle and nonslip foot.

1 Trace or copy the embroidery frame pattern (page 54) onto a folded piece of paper. Cut out the pattern on the outer line, then cut out the center on the dotted line. Open to make a paper frame.

2 Center the embroidered design in the paper frame.

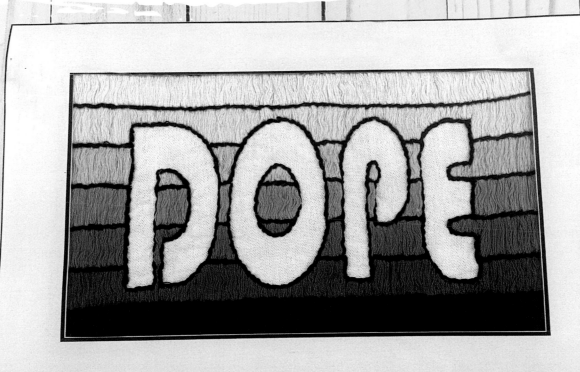

Place on fold of fabric.
Cut out along the dotted line.

EMBROIDERY FRAME

3 Use the paper pattern to trace the outer line on the wrong side of the leather piece. Cut 1 front and 1 back. Use the paper frame to carefully mark and cut the center of the front, and set it aside for the pocket.

4 Apply basting tape to the underside of the frame. Center the embroidered fabric behind the frame, using the basting tape to hold it in place. Stitch around the perimeter of the inside rectangle, ¼" (6mm) from the edge, to secure the embroidery to the frame.

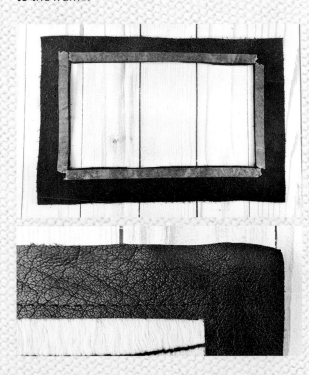

5 On the pouch back, center the pocket horizontally and 1½" (3.8cm) from the top. Secure the pocket sides and bottom with basting tape. Stitch the sides and bottom.

6 Cut 2 leather squares 1½" × 1½" (3.8 × 3.8cm) for zipper stops. Use basting tape to secure the leather over the ends of the zipper. Trim sides to meet the sides of the zipper tape. Stitch the end, across the zipper tape, taking care to avoid the metal teeth of the zipper.

7 Fuse the interfacing to the wrong side of the lining piece. Cut into 2 rectangles 7½" × 9½" (19.1 × 24.1cm).

8 With the right side of the leather facing up, lay the zipper face down on top with edges even. The zipper tail will extend past the fabric. Place 1 lining piece face down over the zipper. Stitch in place using a zipper foot.

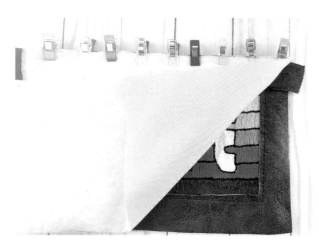

Repeat on the opposite side of the zipper, aligning the top of the pouch back and the second lining piece to the zipper edge.

9 Lay the open pouch flat. Topstitch along the zipper sides, through all layers along the zipper sides. You may want to change the color of your bobbin thread to match the lining fabric.

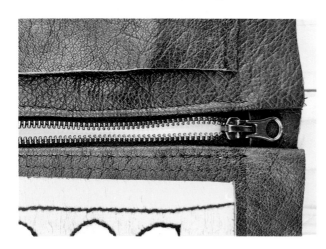

10 *Next, sew each side separately starting at the seam near the end of the zipper and stopping at the other.* To do this, unzip the zipper. Place the lining pieces right sides together and the leather pieces right sides together.

- Secure the leather seams with the fabric clips. Begin at a top side and stitch around the perimeter of the leather pouch with a ¼″ (6mm) seam.

- Pin the lining sides together with a 4″ (10.2cm) opening on the bottom for turning. Stitch with a ½″ (12mm) seam allowance. *This larger seam allowance lets the lining sit in the pouch without buckling.* Clip the corners to reduce bulk.

11 Reach through the zipper opening and turn the bag right side out. Slip stitch or machine stitch the opening in the lining closed.

12 Thread the leather latigo cord through the zipper pull and knot the ends together.

VARIATIONS

- Stitch the pouch with an exposed raw edge and no lining. After embroidering the design, trim the panel to match the length and width of the pouch front. Add basting tape to the frame as instructed *and* to the corners of the panel to secure it to the edge of the pouch. After installing the zipper, fold the bag with wrong sides together so the side seams meet. On the outside stitch the edge with a ¼″ (6mm) seam allowance.

- Embroider other words. See the alternate words (pages 90–93).

If something's dope, you got to go with it.
— TY DOLLA $IGN —

ME TIME
hoop

Finished size:
6˝ (15.2cm) diameter

We are living in a hustle-hard, do-all-the-things, push-through, burn-the-midnight-oil culture. Exhaustion, busyness, and overbooked schedules are worn as badges of honor of *"superwomen" and "strong black women."* We are conditioned to believe we are lazy or unmotivated if we do not give until there is nothing left. Burnout can take a toll on all aspects of our lives and make us ineffective if we work when we should rest. We cannot pour from an empty vessel. Remember to take time for yourself. Make self-care a part of your daily, weekly, monthly, and annual schedule. Get busy doing nothing occasionally.

If you do not take control over your time and your life, other people will gobble it up. If you don't prioritize yourself, you constantly start falling lower and lower on your list.

— MICHELLE OBAMA

materials

NEUTRAL FABRIC: a square 10″ × 10″ (25.4 × 25.4cm) for the background

ASSORTED EMBROIDERY FLOSS: 1 skein each of color. See the embroidery stitch guide (page 59) for floss colors.

EMBROIDERY HOOPS: 6″ (15.2cm) for display and 8″ (20.3cm) for stitching

EMBROIDERY PATTERN (page 111)

INSTRUCTIONS

See Getting Started (page 8) for information on marking fabric, transferring images, finishing your hoop, and other techniques.

EMBROIDERY

1 Center the iron-on pattern on top of the background fabric. Transfer the design to the fabric with a medium-hot iron. If you want to change the iron-on design or use a design from the Embroidery Design Gallery, see Transferring Patterns (page 11).

2 Secure the fabric in the 8″ hoop. You need the larger hoop to stitch this design, because the background fabric will extend past the edge of the 6″ display hoop.

3 Embroider the design. Refer to the stitch guide (page 59) to see which stitch, floss color, and number of strands to use for each element of the design.

FINISHING

1 Press the embroidery and transfer it to the smaller 6″ (15.2cm) hoop.

2 Finish the back side of the hoop. See Hoop Finishing (page 14).

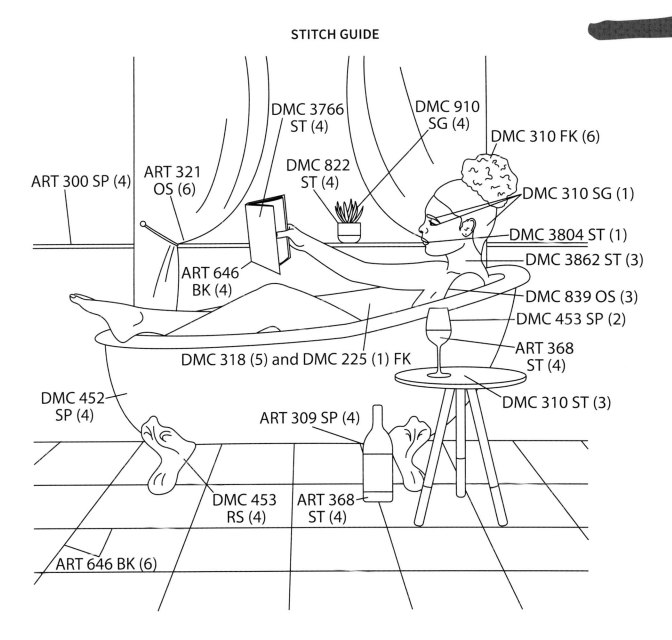

DMC 3766 ST (4)

DMC 910 SG (4)

DMC 310 FK (6)

ART 300 SP (4)

ART 321 OS (6)

DMC 822 ST (4)

DMC 310 SG (1)

DMC 3804 ST (1)

DMC 3862 ST (3)

ART 646 BK (4)

DMC 839 OS (3)

DMC 453 SP (2)

ART 368 ST (4)

DMC 318 (5) and DMC 225 (1) FK

DMC 310 ST (3)

DMC 452 SP (4)

ART 309 SP (4)

DMC 453 RS (4)

ART 368 ST (4)

ART 646 BK (6)

You know what? Especially with women, we are usually the caretakers of everyone except for ourselves. If I don't take care of myself and I'm taking care of my daughter or my husband or whatever—I'm running on fumes. I have nothing left to give. Nothing. But when I take the time to take care of myself, to go to the doctor, go to a spa, get a deep-tissue massage, get adjusted by chiropractor ... I feel like I can face life with a renewed vigor and renewed passion. — **VIOLA DAVIS**

SQUAD GOALS

Finished size: 14″ × 11″
(35.6 × 27.9cm)

canvas art

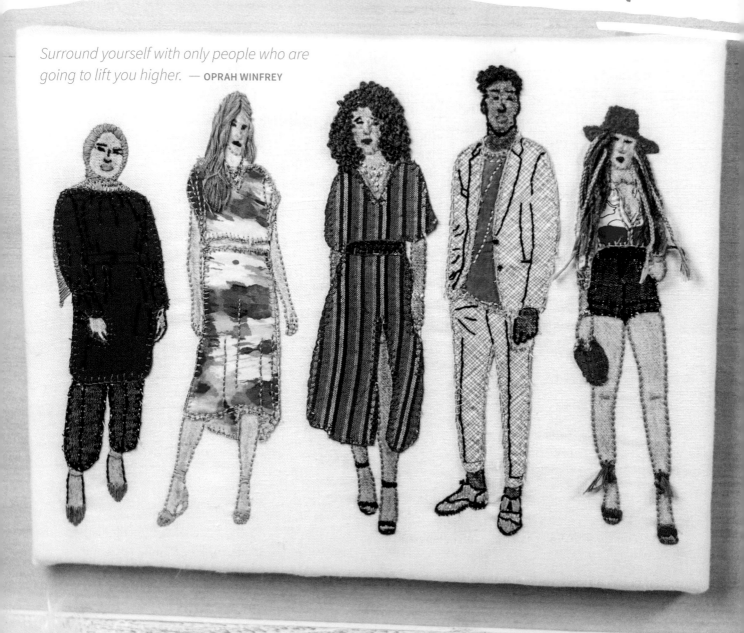

Surround yourself with only people who are going to lift you higher. — **OPRAH WINFREY**

As a child, I loved to color and play with paper dolls. I loved designing their multiple outfits and making up scenarios for where they were going and what they would do. It was always fun to try to make them look like my family and my diverse friends by changing their hair, skin, and clothing. With *Squad Goals*, I reminisce on what it was like to play with paper dolls as I depict a circle of friends.

materials

Neutral color fabric: a rectangle 18″ × 15″ (45.7 × 38.1cm) for the main top

Neutral color felt, batting or flannel:
a rectangle 16″ × 13″ (40.6 × 33cm)

Assorted embroidery floss: 1 skein each of color (The colors of the floss and fibers are omitted on the stitch guide because they correspond to the specific fabrics chosen.)

Assorted fabric scraps: in various sizes for appliqués

Utility knife for cutting fine details

Double-sided fusible interfacing for fabric appliqué

Embroidery hoop: 10″ (25.4cm). This is a good size for stitching the small features but will require repositioning.

Stretched art canvas frame: a frame 14″ × 11″ (35.6 × 27.9cm)

Smooth-back thumbtacks: At least 30

Glassless wood frame (optional): 15¾″ × 19¾″ × 1⅜″ (40 × 50.2 × 3.5cm)

Heavy-duty double sided tape (optional):
4″ (10.2cm) cut into 4 pieces 1″ (2.5cm) in length

Art easel (optional): 16″ × 9″ (40.6 × 22.9cm)

Plush towel to cushion the embroidery when mounting

Embroidery patterns (page 113).
See alternate figures (pages 75 and 76).

INSTRUCTIONS

See Getting Started (page 8) for information on marking fabric, transferring images, finishing your hoop, and other techniques.

EMBROIDERY

1 Use a disappearing marking tool to draw a line along the bottom of the fabric, about 3″ (7.6cm) from the edge. Use this as a guide to align the bottom of the figures. Arrange the individual iron-on figures on the background fabric, about ½″ (12mm) apart. Transfer the images to the fabric with a medium-hot iron.

If you want to change the iron-on designs or use a design from the Embroidery Design Gallery, see Transferring Patterns (page 11). If you mix and match other images from the gallery, you may need to adjust the arrangement to account for the different widths and heights of the figures.

2 Color the skin of the figures. See Crayon Tinting (page 12).

3 Follow the steps to appliqué and stitch the elements (page 13).

4 Embroider the body and hair details. Refer to the stitch guides (page 62) to see which stitch, floss color, and number of strands to use for each element of the design.

5 Trim the embroidered panel to 16″ × 13″ (40.6 × 33cm) to match the batting.

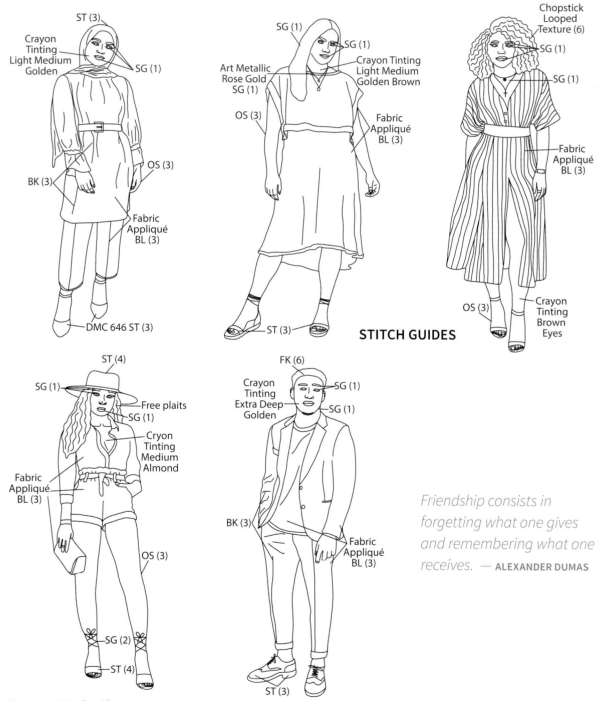

ST (3)
Crayon Tinting Light Medium Golden
SG (1)
BK (3)
OS (3)
Fabric Appliqué BL (3)
DMC 646 ST (3)

SG (1)
SG (1)
Art Metallic Rose Gold SG (1)
Crayon Tinting Light Medium Golden Brown
OS (3)
Fabric Appliqué BL (3)
ST (3)

Chopstick Looped Texture (6)
SG (1)
SG (1)
Fabric Appliqué BL (3)
OS (3)
Crayon Tinting Brown Eyes

STITCH GUIDES

ST (4)
SG (1)
Free plaits SG (1)
Cryon Tinting Medium Almond
Fabric Appliqué BL (3)
OS (3)
SG (2)
ST (4)

FK (6)
Crayon Tinting Extra Deep Golden
SG (1)
SG (1)
BK (3)
Fabric Appliqué BL (3)
ST (3)

Friendship consists in forgetting what one gives and remembering what one receives. — ALEXANDER DUMAS

FINISHING

1 With the design face up, center the embroidered panel on the batting. *The batting should hold both together without shifting. If it moves, add a stitch at each corner so they behave as one.*

2 Center and smooth the panel over the canvas frame. When you are pleased with the placement, temporarily tack the fabric and batting at the sides to hold them in place.

3 Work on a towel so you do not crush the embroidery. Flip the frame over. Fold the fabric over the frame and begin tacking it in place on the long sides. Alternate tacks on the top and bottom of the frame.

4 Flip to check the position and tension on the front. If necessary, remove tacks and readjust.

5 Trim the batting at the corners to reduce bulk.

6 Fold the short sides in over the long sides.

7 Continue to tack in place on opposite sides.

8 Remove the anchor tacks from the sides.

9 Finish the back with cardstock. See hoop finishing (page 14).

10 For frame mounting, center the canvas in the frame and mark the corners. Place a piece of double-sided mounting tape at the corners. Press the frame in place over the tape to secure it.

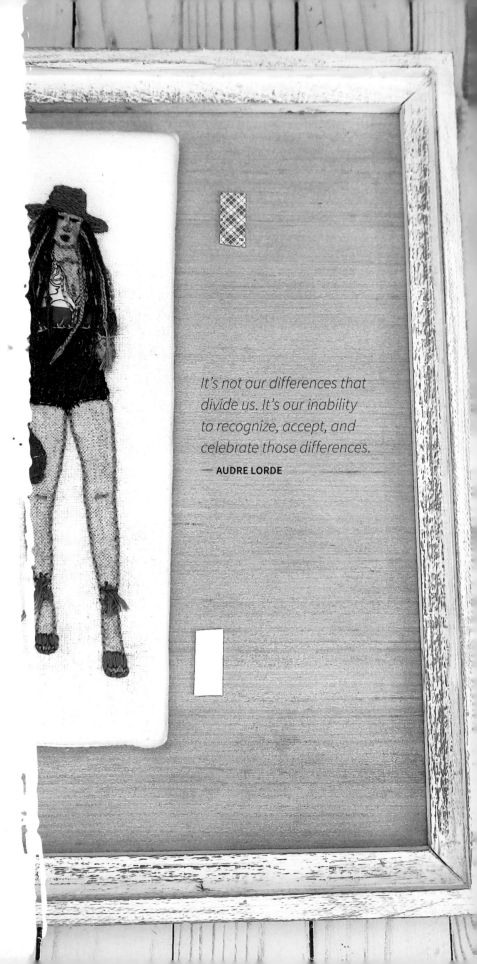

It's not our differences that divide us. It's our inability to recognize, accept, and celebrate those differences.

— AUDRE LORDE

WORK-IN-PROGRESS
denim jacket sampler

Finished size: Depends on the size of your jacket

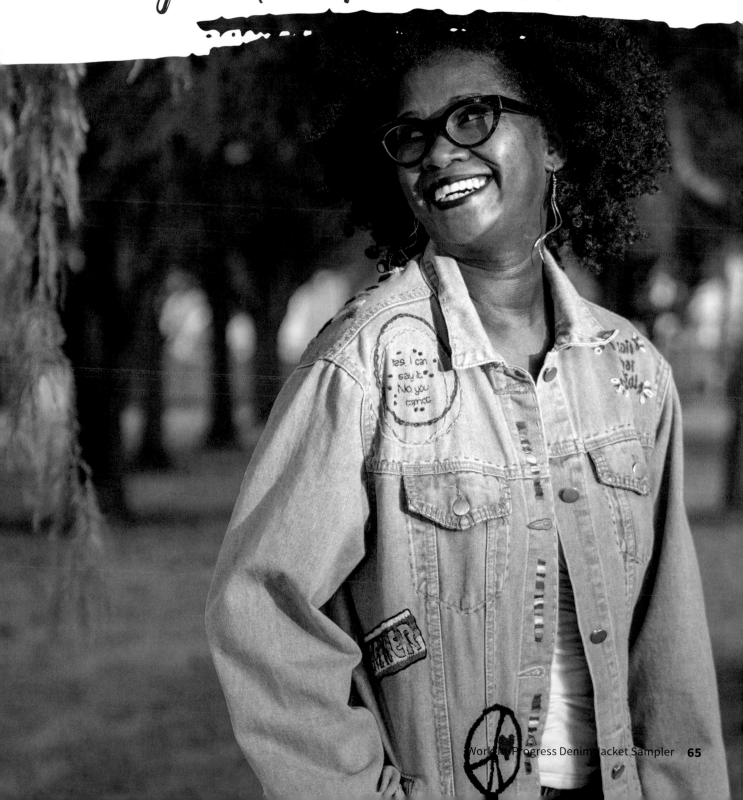

Perfection, completion, and self-actualization are enemies of progress. I love the phrase "work in progress." It acknowledges what has been done and what is yet to be. I love the look of embroidered denim jackets and the stories they can tell. For this project, sort through the designs, both in the gallery (page 69) and the iron-on designs (page 97). Choose those that speak to you and take your time stitching. Experiment with stitches and fibers to add a range of textures to your final piece. Use this piece as a stitch sampler that you work on continuously, adding more depth, detail, and beauty over time.

Don't wait until you've reached your goal to be proud of yourself. Be proud of every step you take toward reaching that goal. — SIMONE BILES

materials

100% COTTON DENIM JACKET: If you choose a jacket with a spandex blend, in time there may be shifting of the design because of the elasticity of that fiber. I do not recommend it.

EMBROIDERY HOOPS: Assorted sizes to accommodate your chosen designs

CREWEL OR TAPESTRY NEEDLES: Strong enough to go through denim

LEATHER THIMBLE OR THREAD PULLERS

FABRIC CLIPS

ASSORTED EMBROIDERY FLOSS, 12-WEIGHT CROCHET THREADS AND PERLE COTTON THREADS

EMBROIDERY PATTERNS: Your choice! I used a peace symbol, a fist, mixtape, earrings, headphones (with an added free-form cord) semicolon, heart, picks, the back of an afro, "no" symbol, and a lot of words—"Girl, Bye," "No, you can't touch my hair!," "Loved," "Maker," "Represent," "Won't he do it!," "Blessings on Blessings," "I said what I said," "Good vibes," and "Blessed," all in Iron-On Embroidery Designs (page 97). But to make the jacket truly your own, leaf through the Embroidery Design Gallery (page 69) for other options, including some alternates for "Loved" and "Maker" or even copy and change the size of the patterns on the iron-on pages.

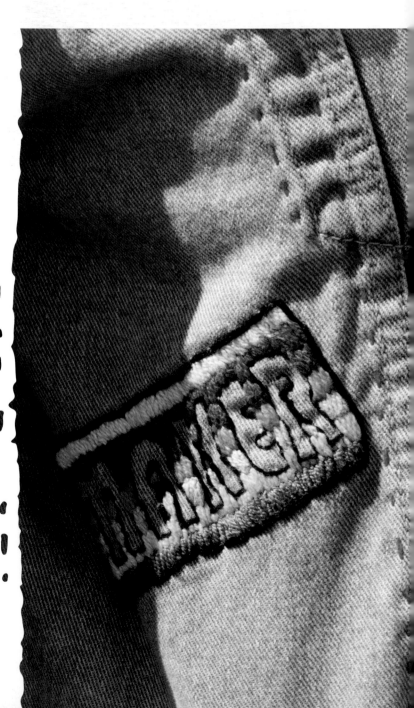

INSTRUCTIONS

1 Transfer the designs to the fabric with a medium-hot iron. Consider the placement carefully. *The fabric in the areas where the seams meet is very dense and requires more force to stitch through. Consider larger stitches in these areas.*

Feel free to add your own touches. For example, when I stitched my headphones, I added a wavy cord underneath to give it more weight.

Also, you might recognize the style of "Maker," which is a small version of Dope from the Dope Zipper Pouch (page 51). To use Dope or one of the alternate words (pages 90–93), just copy and reduce the size of the large design to fit the space on your jacket.

2 Secure the fabric in the hoop. Use fabric clips to hold the fabric out of the way while you stitch.

3 Embroider the designs using various fibers and techniques. I used the full 6 strands of the fibers for most of the designs so they are visible on the dense fabric. Reposition the hoop as needed.

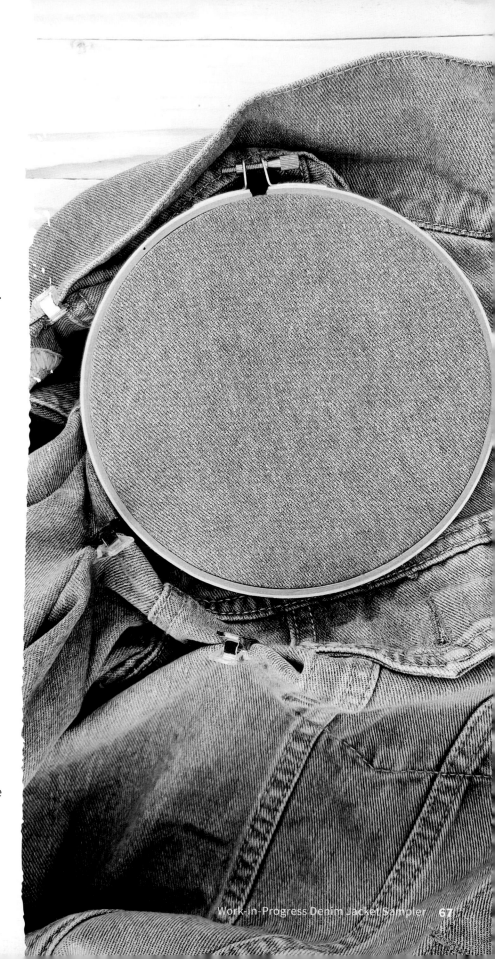

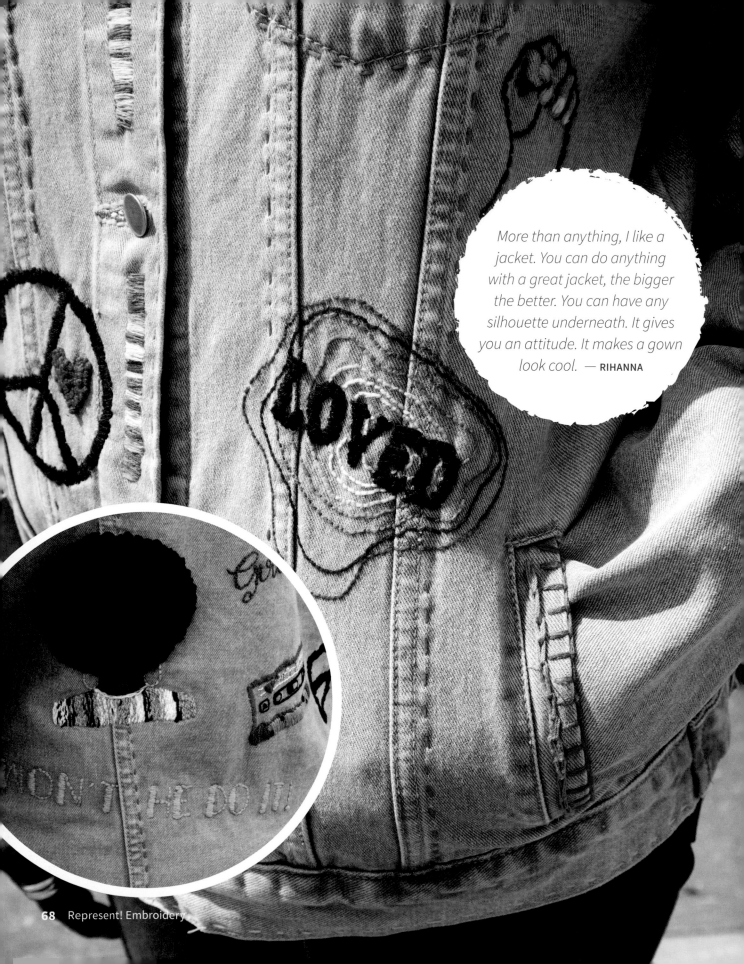

More than anything, I like a jacket. You can do anything with a great jacket, the bigger the better. You can have any silhouette underneath. It gives you an attitude. It makes a gown look cool. — **RIHANNA**

Embroidery
DESIGN GALLERY

For embroidery patterns from this page, refer to the pages noted.

88

I jump to put these jeans on! 82

71

MAKING QUEEN MOVES

ALLIES ACCOMPLICES! 83

87

Unbothered by the opinions of shrimp.

79

91

MAKER

80

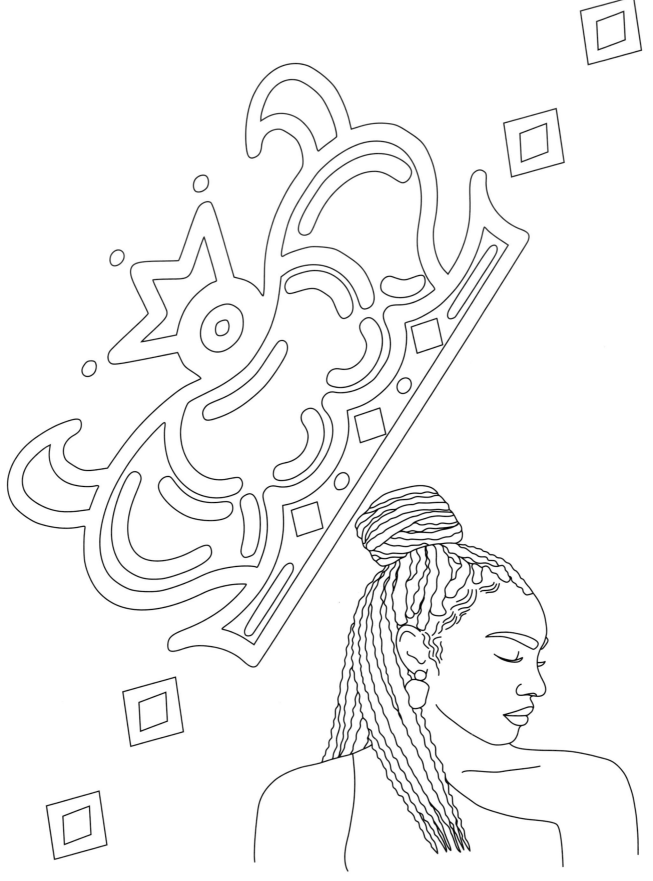

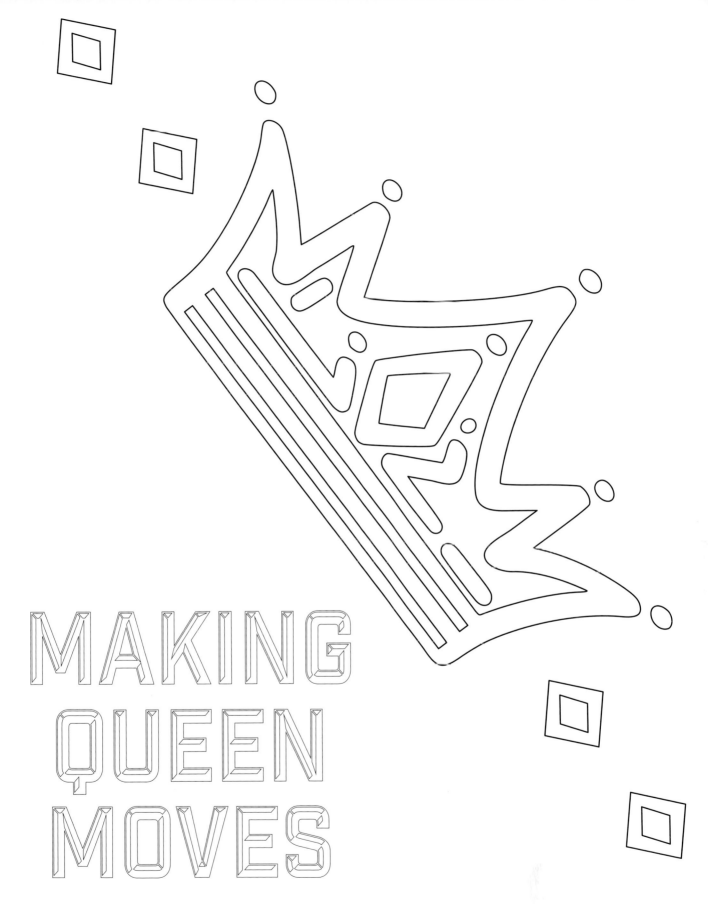

MAKING QUEEN MOVES

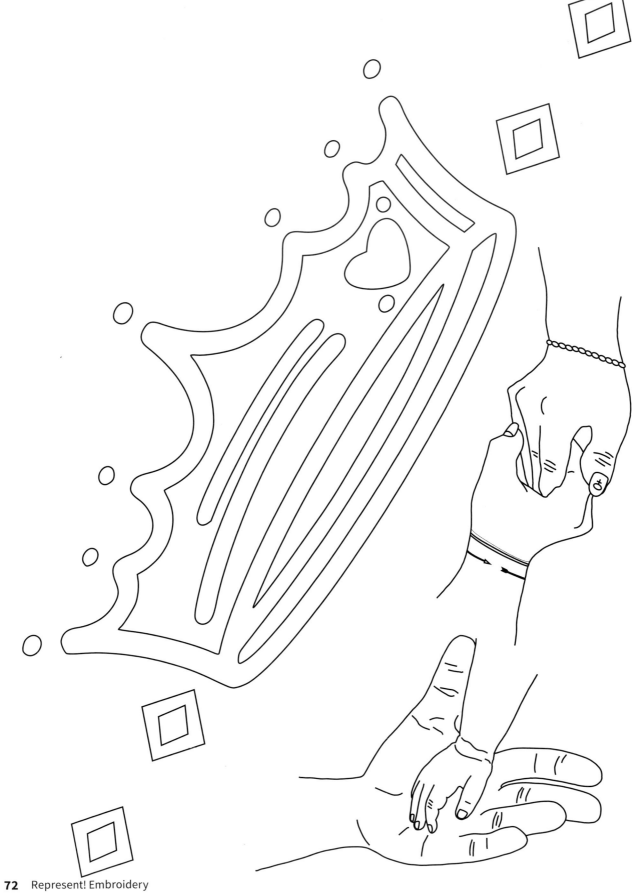

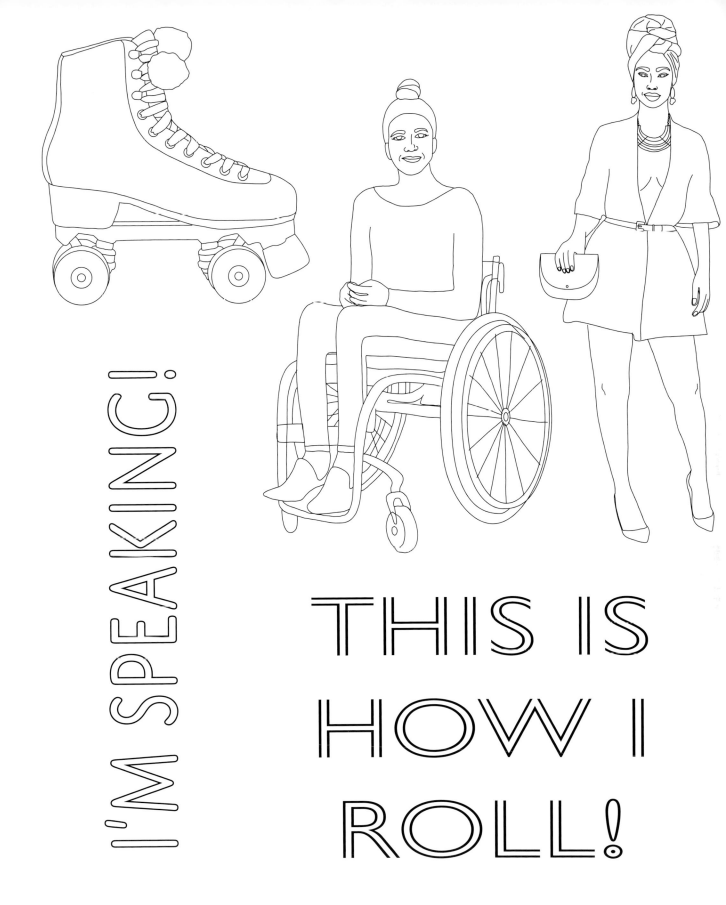

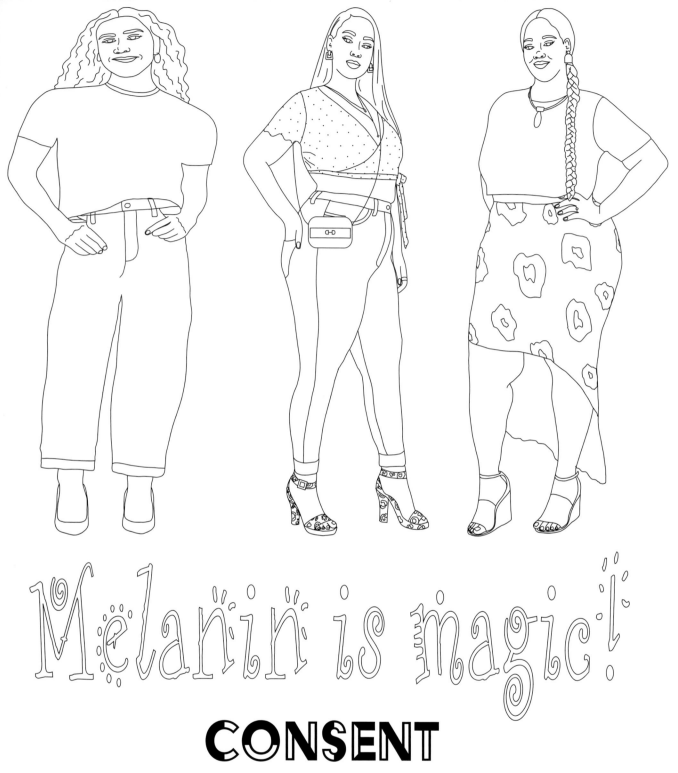

Melanin is magic!

CONSENT
IS
MANDATORY

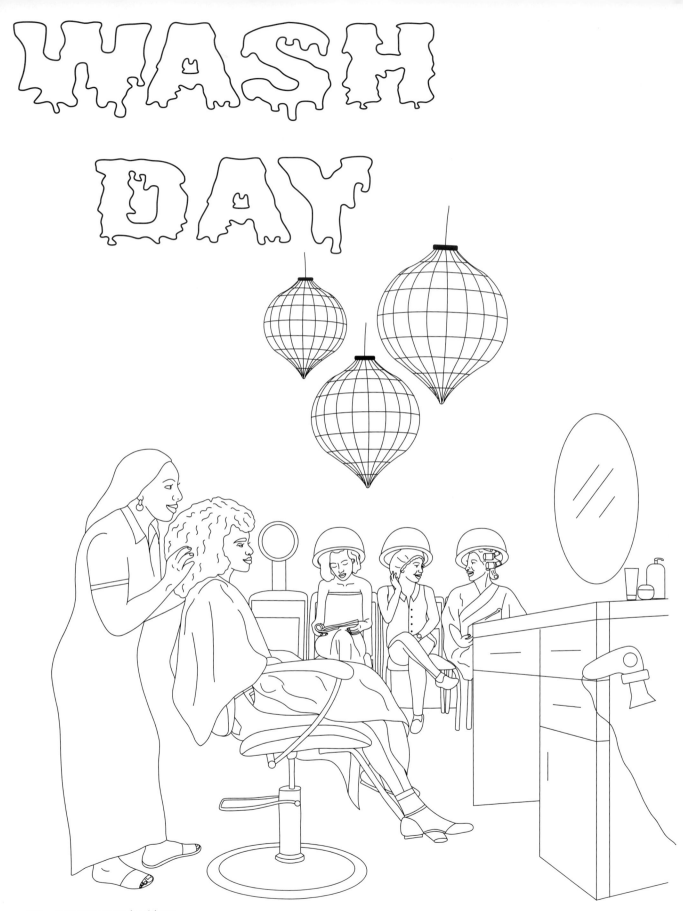

Minding my own business.

You should try it!

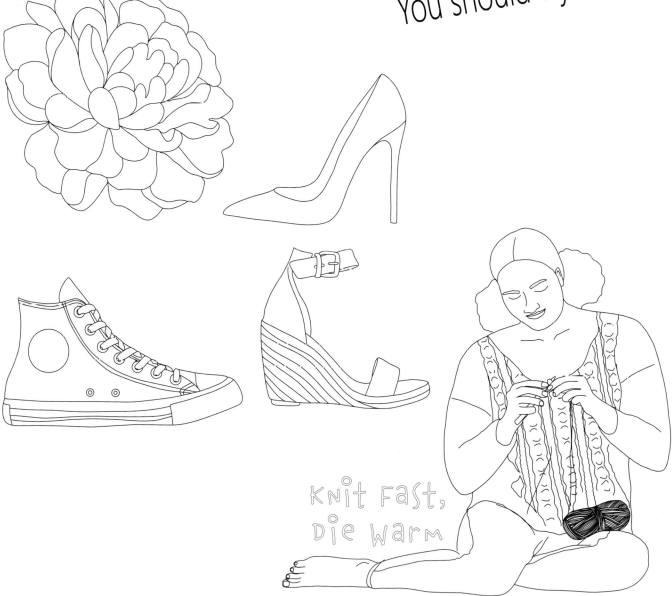

Knit Fast, Die Warm

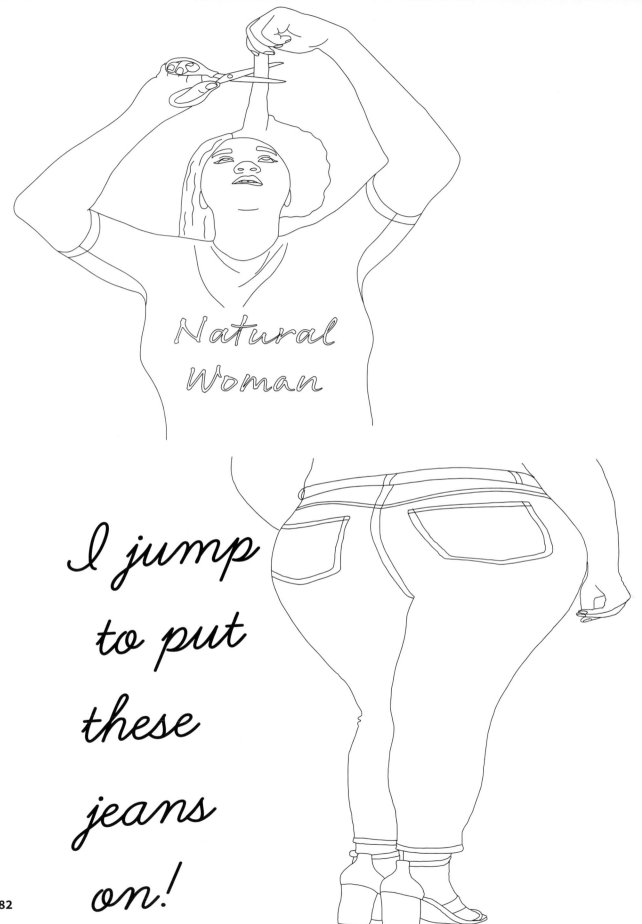

Natural Woman

I jump to put these jeans on!

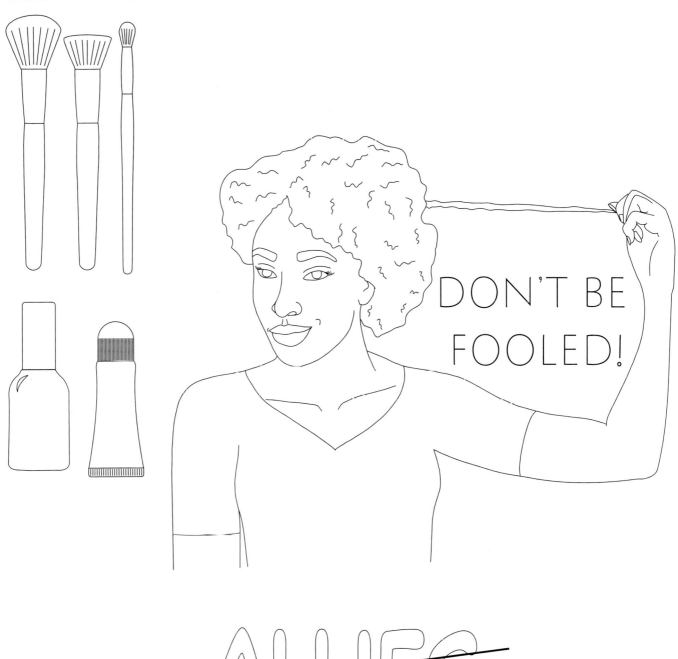

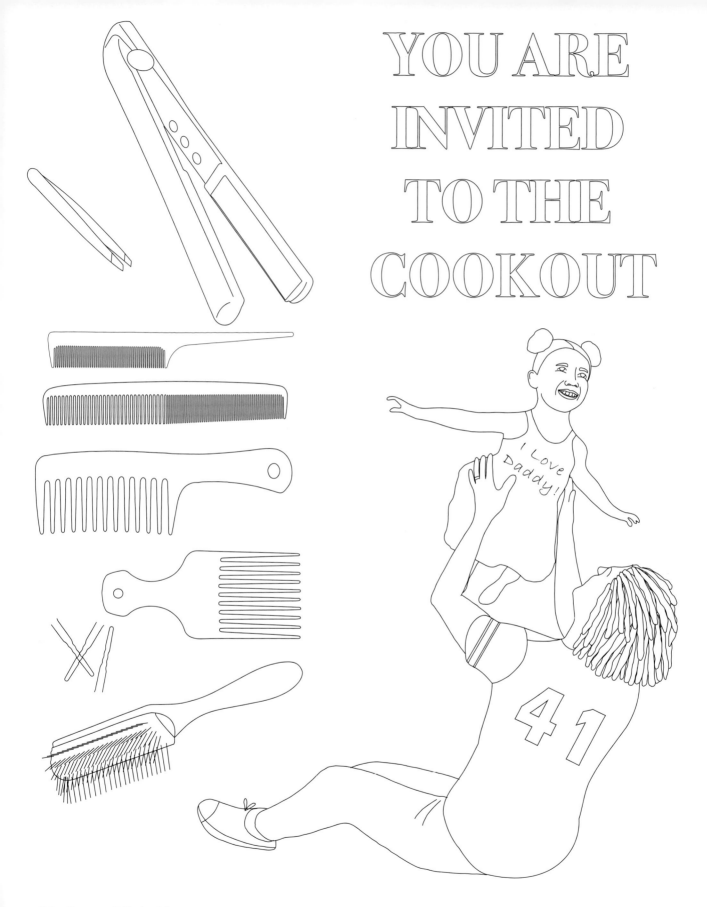

YOU ARE INVITED TO THE COOKOUT

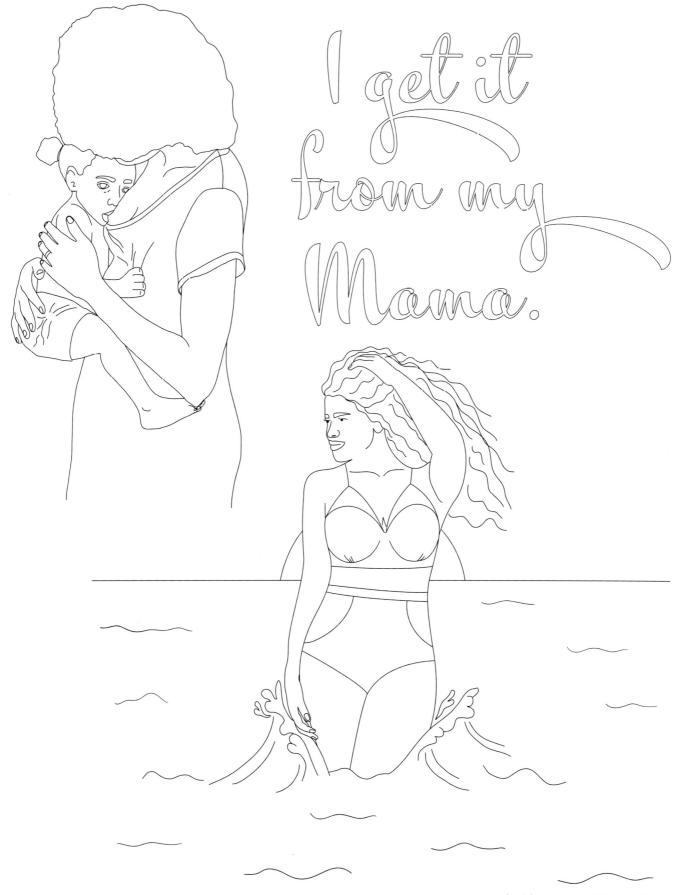

I get it from my Mama.

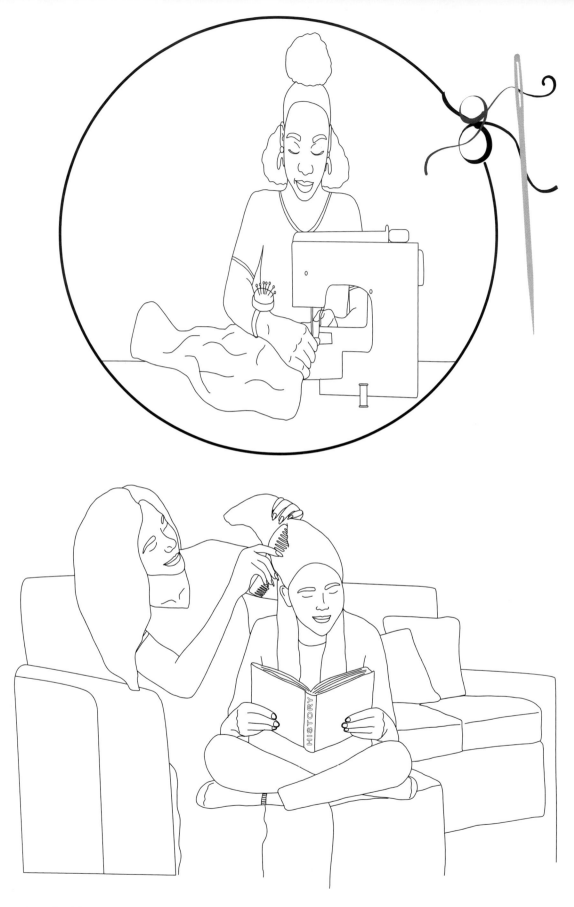

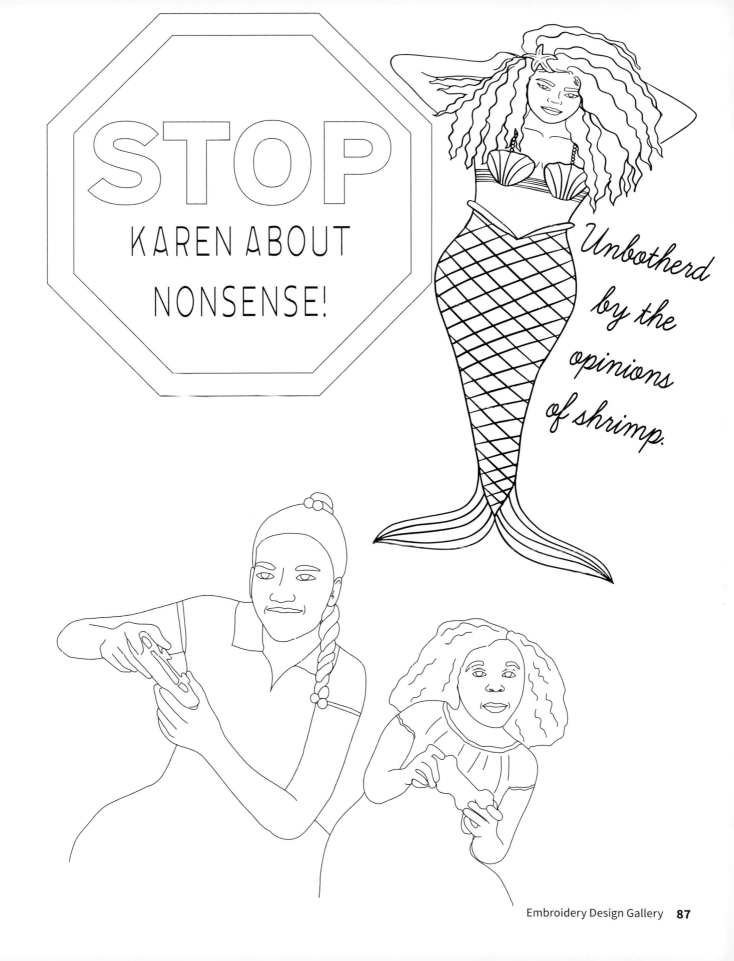

IT'S THE
BLACK
BOY JOY
FOR ME!

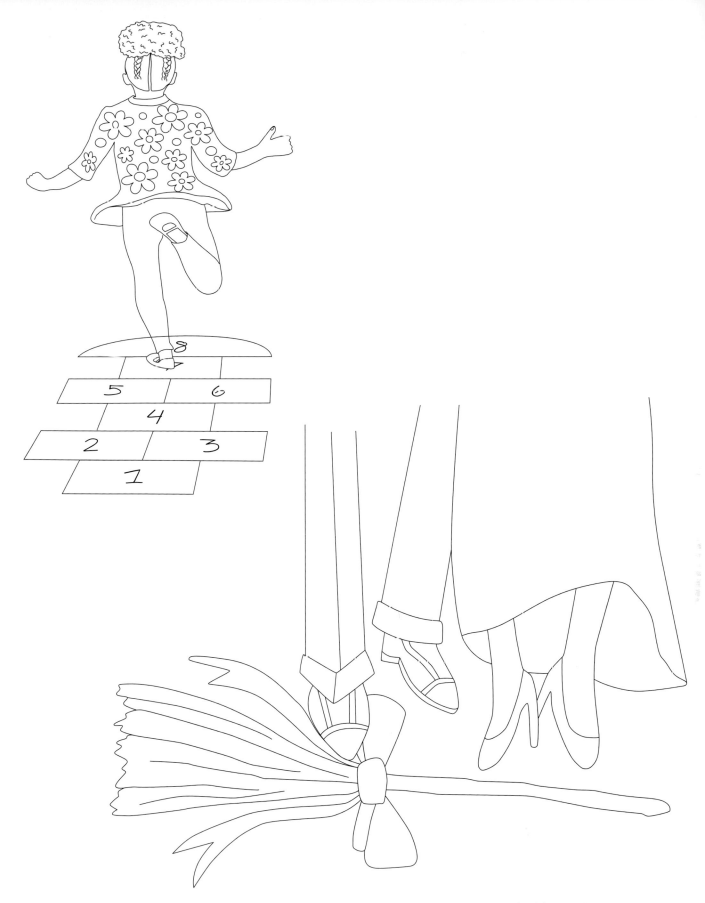

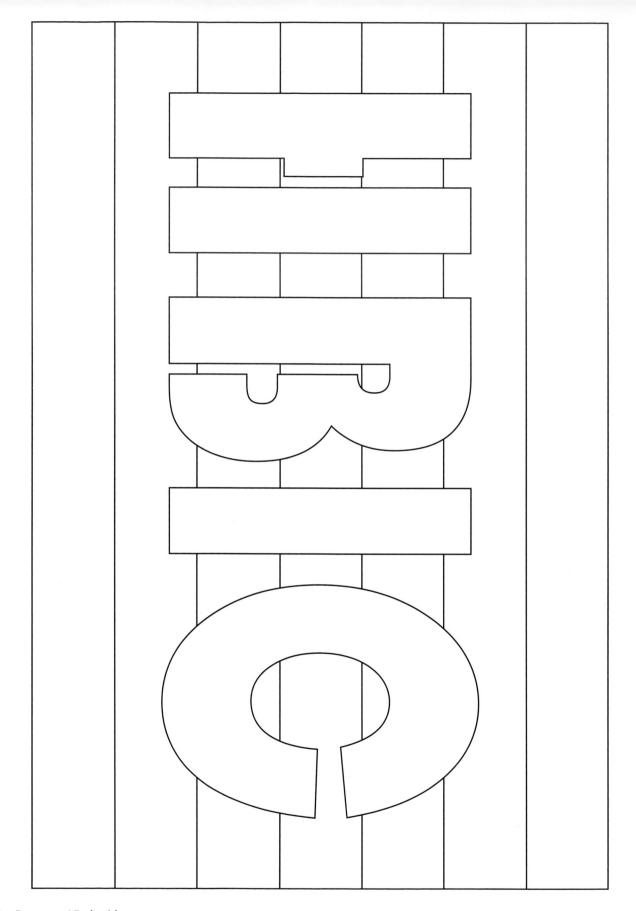

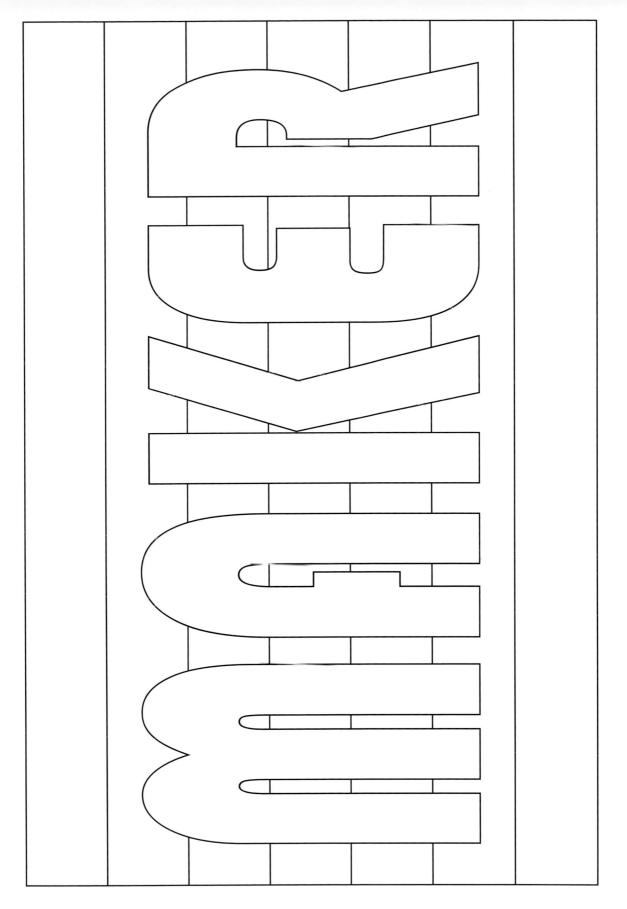

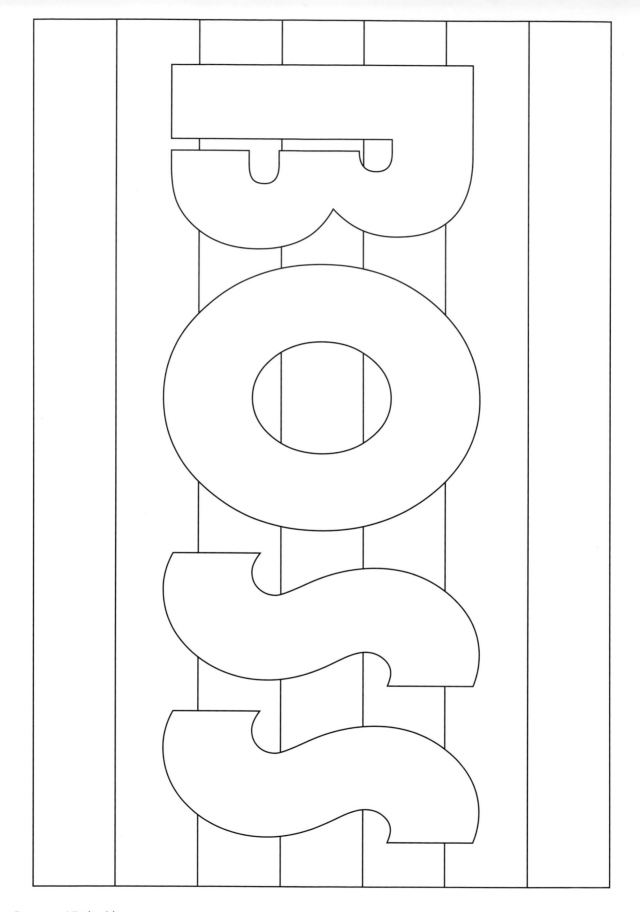

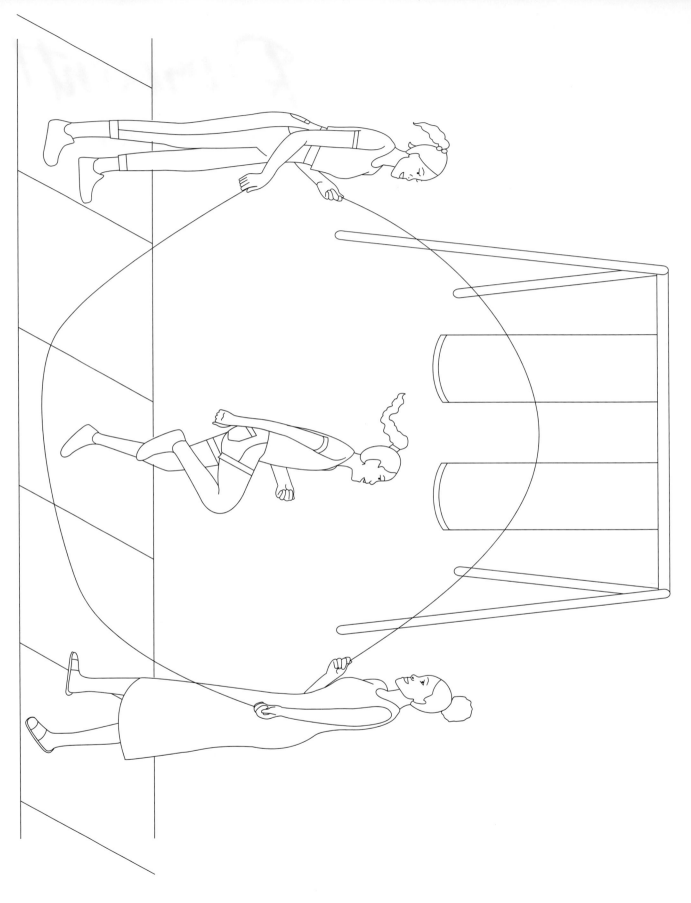

About the Author

BIANCA SPRINGER is primarily a garment sewer and instructor who enjoys a wide range of creative outlets. Bianca is an island girl from Nassau, Bahamas, and currently resides in the Texas Gulf Coast with her husband and two children. She was raised by a maker and has sewn most of my life. Her passion was reignited when she became a mother and began sewing for her children.

She was disheartened to see the lack of representation in fabric collections, pattern covers, and design books. She decided to create what was missing so her children could feel seen, relevant, and valued. She derives much inspiration from her children by using fabric to fill cultural and racial representational gaps in their world and, by extension, the world around them. Bianca designs, makes, and sells sewing pattern weights to improve the speed and efficiency of pattern and fabric cutting. She is a contributing author and editor for *Sew News Magazine* and *Creative Machine Embroidery*.

Bianca loves experimenting with new techniques and constantly asks the question, "I wonder what will happen if?" and "Why sew boring?" Bianca enjoys finding new ways to repurpose textiles and use what is readily available. Bianca loves sharing her passion for sewing with anyone who is willing to learn. As a sewing instructor, she is invigorated by the joy of discovery and sense of accomplishment when a skill "clicks" with a student. Bianca will hem your pants, at a cost, but prefers to teach you how, knowing the satisfaction you will gain.

Instagram: @thanksimadethem

Website: biancaspringer.com

Facebook: /Thanksimadethem

Etsy: /thanksImadeThem

Represent!

IRON-ON DESIGNS

Represent!

IRON-ON DESIGNS

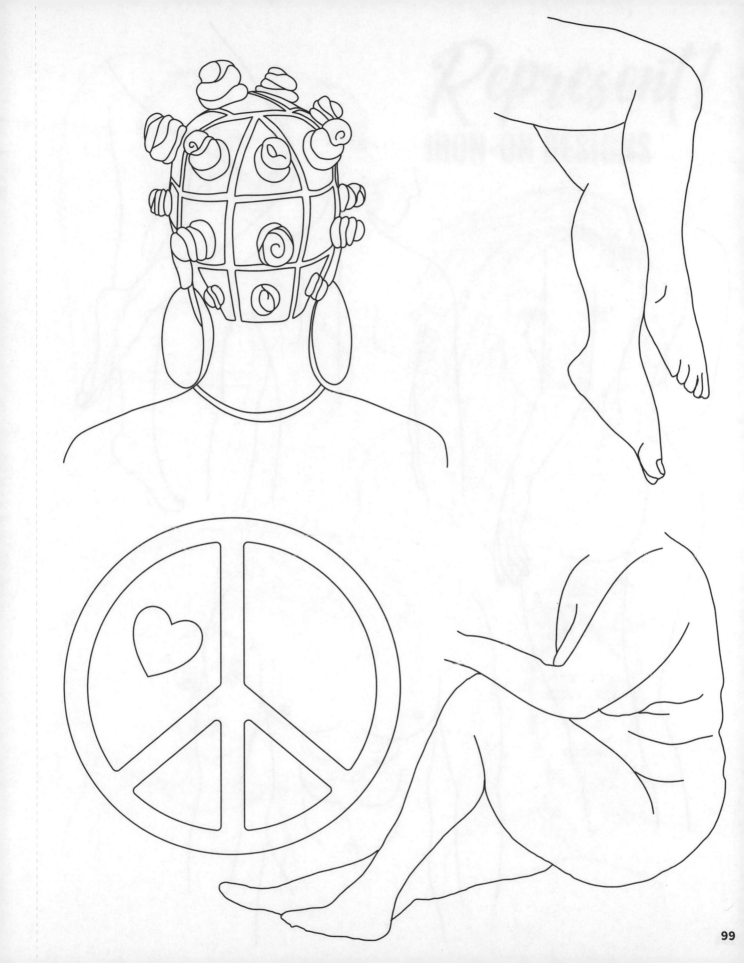

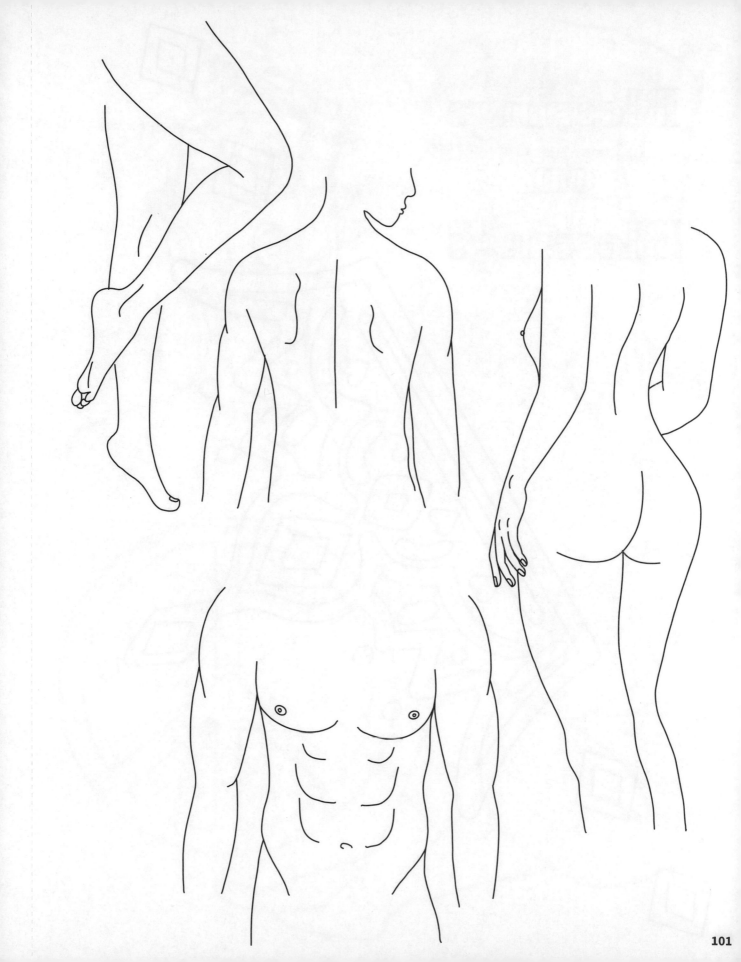

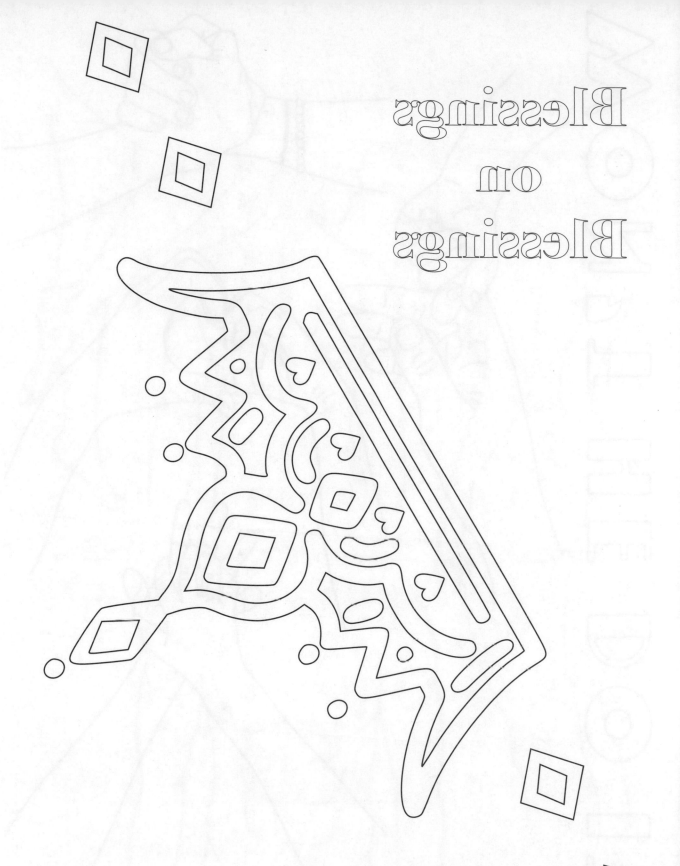

Blessings on Blessings

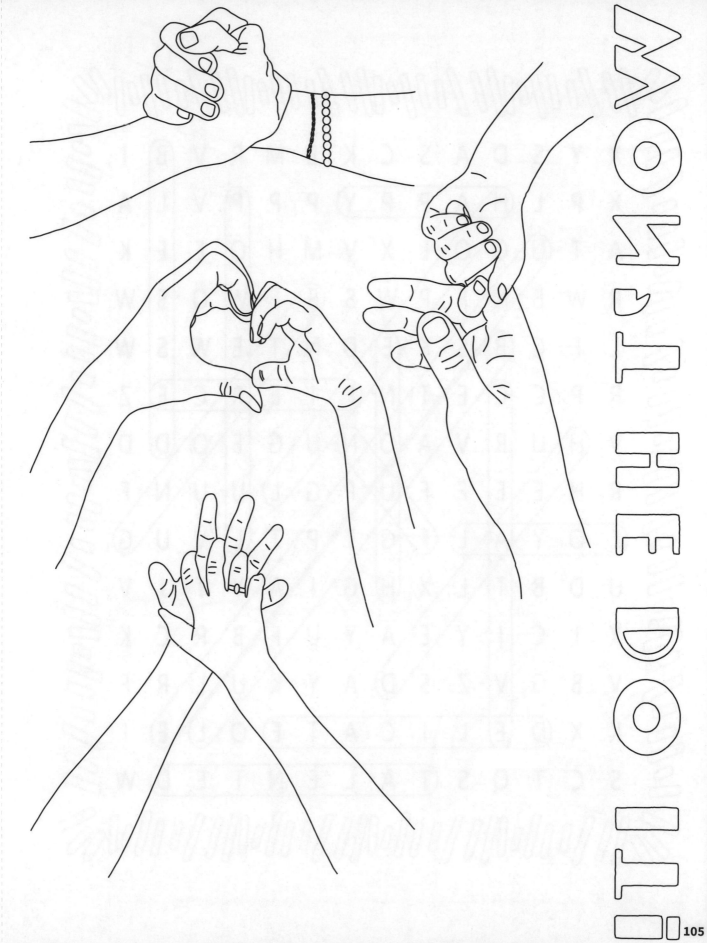

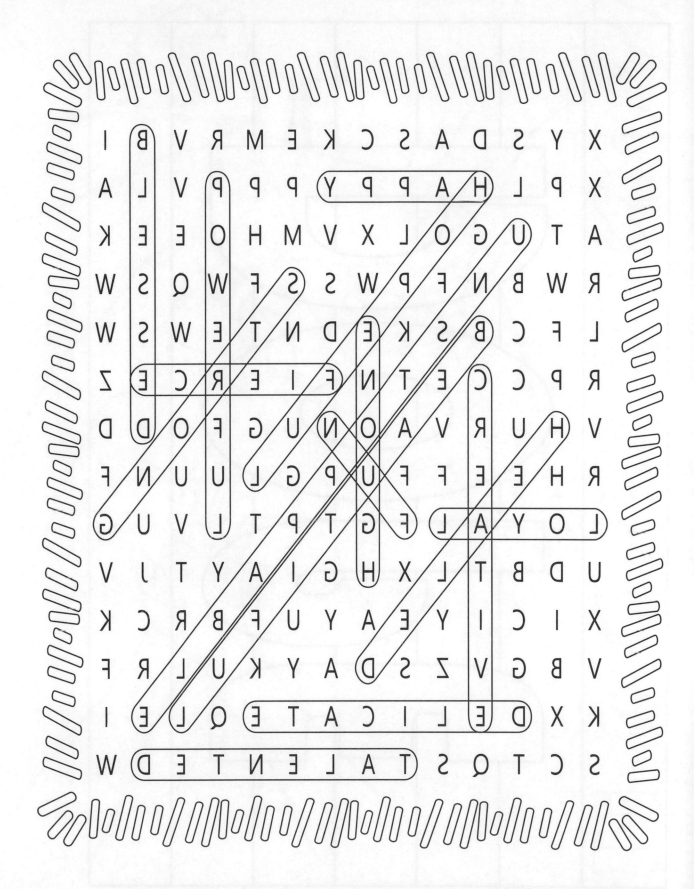

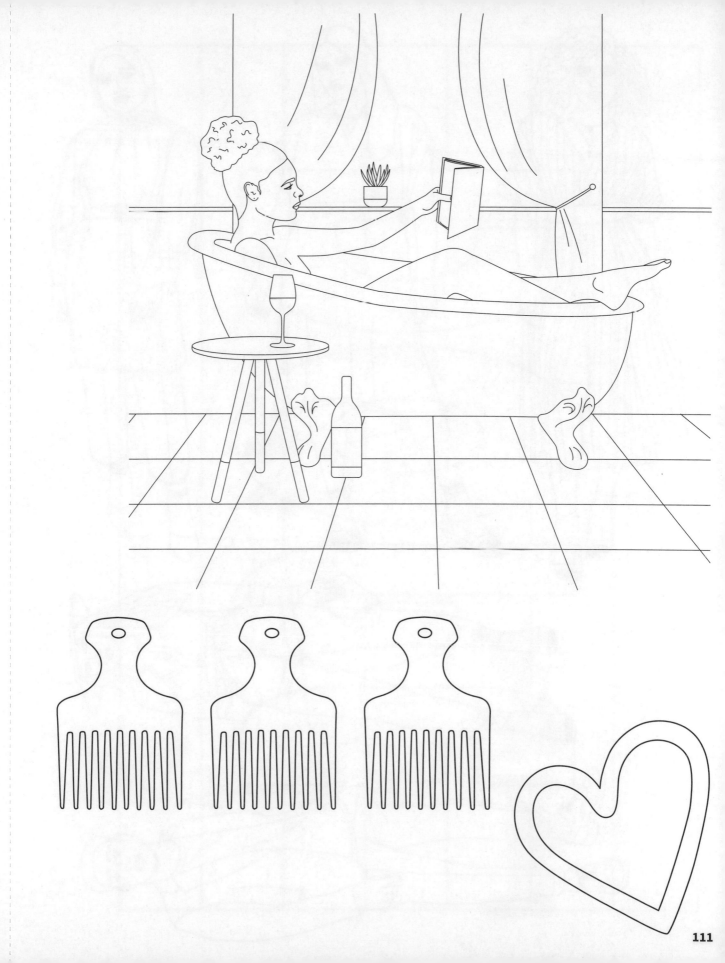

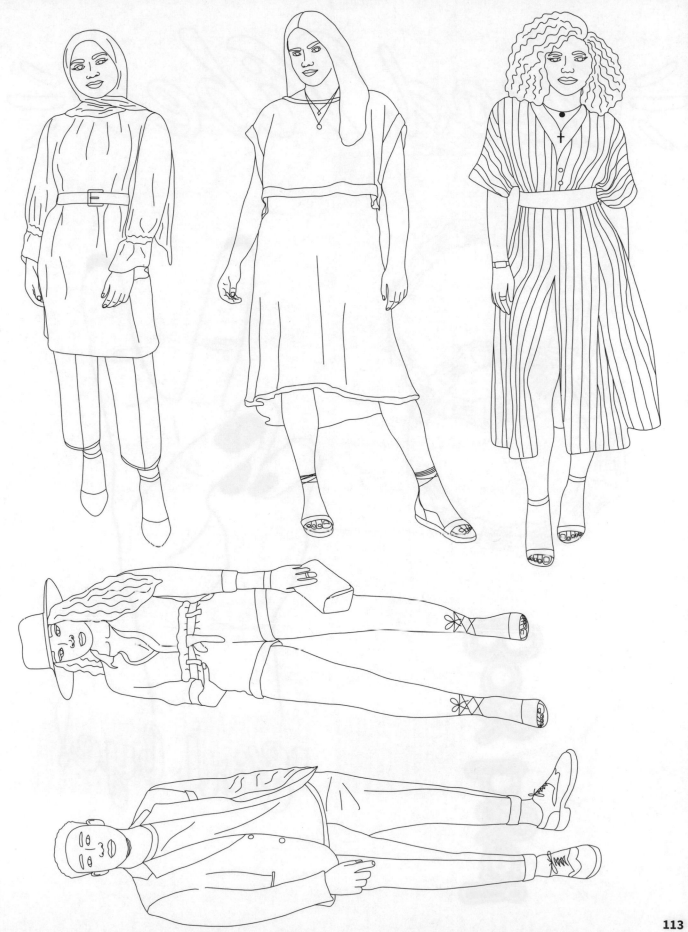

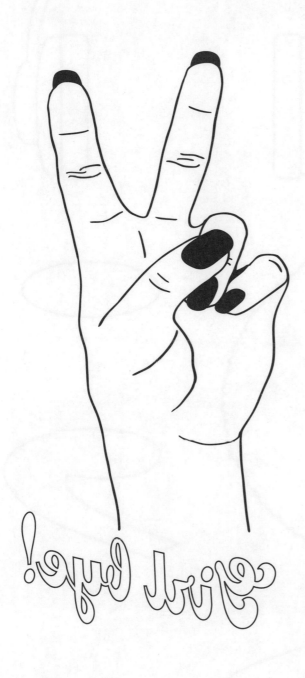

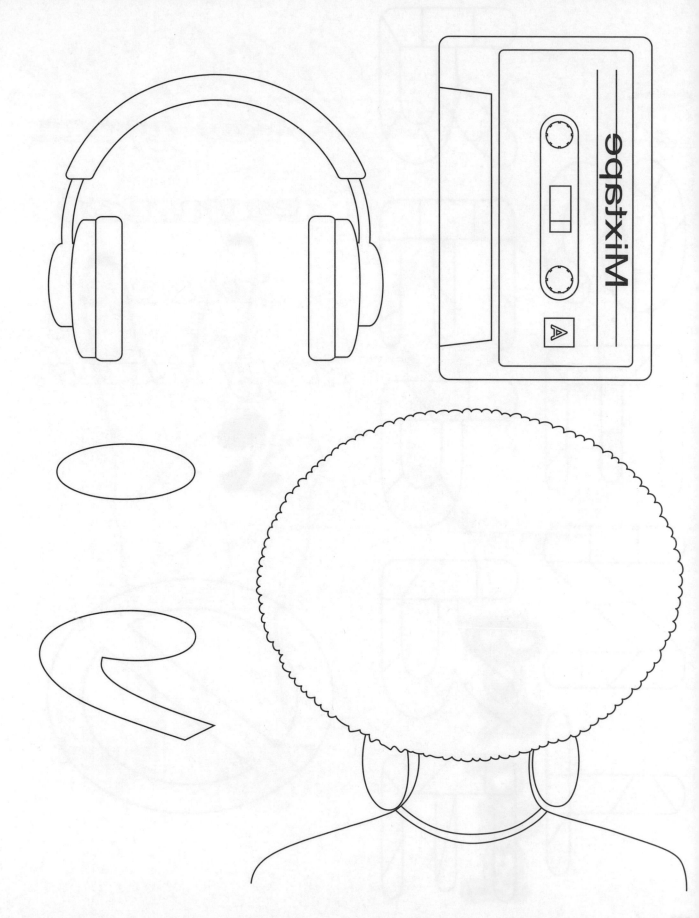

No, you
cannot
touch
my hair.

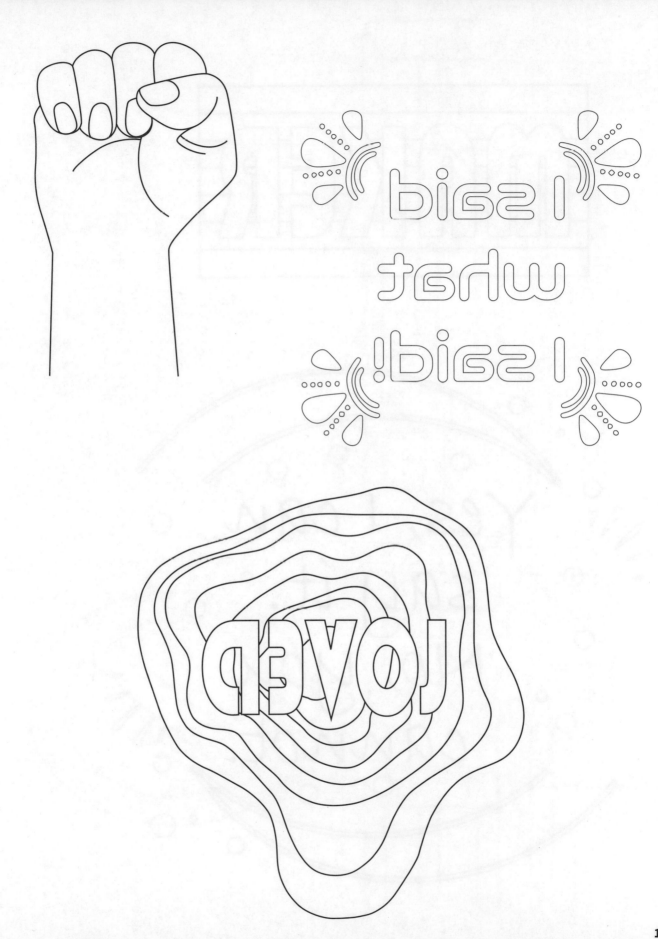

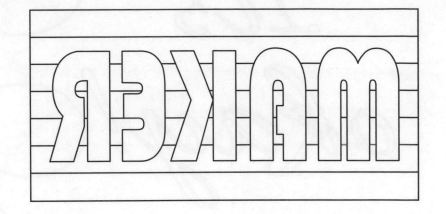

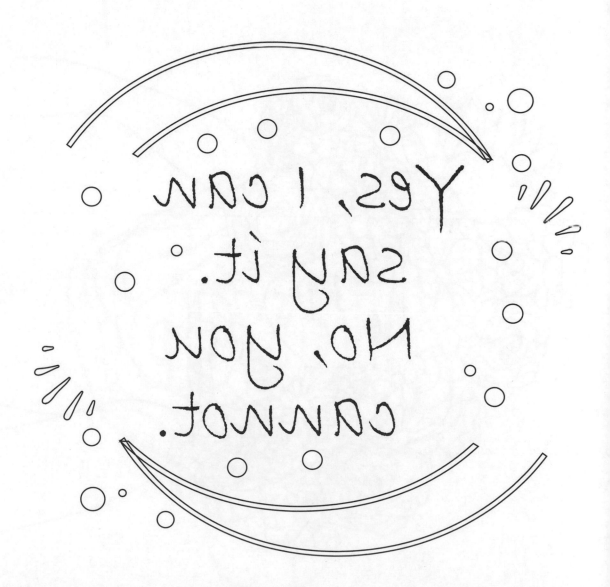

Yes, I can
say it.
No, you
cannot.

It's MAKER day?

Yes, I can say it.
No, you cannot.

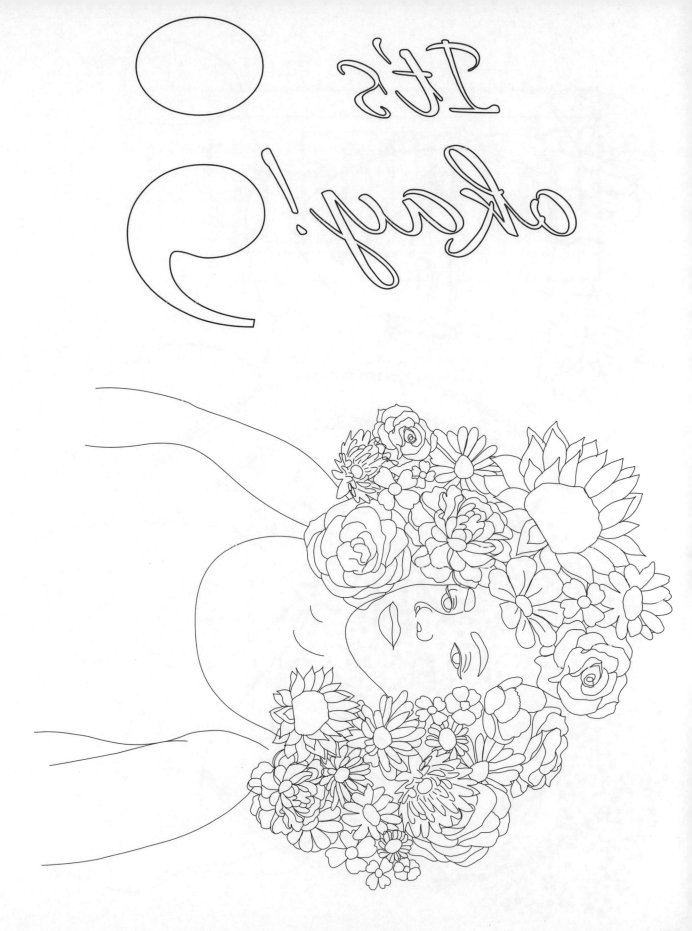

It's
okay!

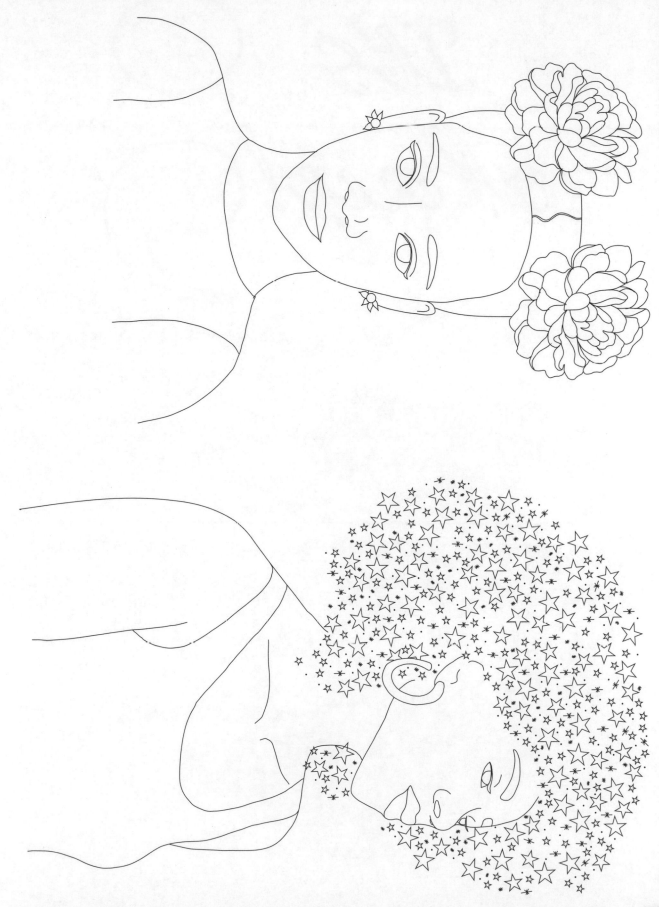